ACRYLIC PAINTING FOR THE BEGINNER

ACRYLIC PAINTING FOR THE BEGINNER

BY FREDERIC TAUBES

WATSON-GUPTILL PUBLICATIONS / NEW YORK

Paperback Edition
First Printing, 1981

First published in 1971 in the United States and Canada by Watson-Guptill Publications,
a division of Billboard Publications, Inc..
1515 Broadway, New York, N.Y. 10036

Library of Congress Catalog Number: 77-137424
ISBN 0-8230-0060-5
ISBN 0-8230-0061-3 pbk.

Manufactured in Japan
4 5 6 7 8 9 10 / 94 93 92 91 90

CONTENTS

Foreword, 7

1. The Nature of Acrylics, 11

Permanence, 11
Chemical Behavior, 11

2. Materials and Equipment, 13

Support, 13
Stretching a Canvas, 13
Priming a Canvas, 14
Priming a Panel, 19
Cardboard and Illustration Board, 19
Paper, 20
Other Supports, 20
Bristle Brushes, 20
Sable Brushes, 23
Soft Hair Blender, 23
Painting Knife, 23

3. Diluents, Varnishes, and Solvents, 24

Acrylic Medium, 24
Acrylic Gel, 24
Acrylic Varnish, 24
Paint Removers, 24

4. Colors, 26

Preparation, 26
List of Colors, 26
Placing Colors on the Palette, 27
Characteristics of Colors, 27
Notes on Color Mixtures, 28

5. Glazes, Watercolor and Gouache Techniques, 30

Diluting Glazes, 30
Supports for Glazing, 30
Multiple Glazes, 31
Watercolor Technique, 31
Gouache and Casein Techniques, 32

6. Scumbling and Opaque Painting, 33

Notes on Technique of Scumbling, 33
Some Examples of Scumbling, 33
Gloss, 35
Opaque and Impasto Painting, 35

7. Still Life and Flower Painting, 36

Beginning a Still Life, 36
First Underpainting, 36
Second Underpainting, 37
Brushes, 37
The Finished Painting, 38
Design, 38
Open Color, 38
Flower Painting, 39
Underpainting Vegetation, 39
Background, 39
Materials and Techniques, 39

8. Landscape, 45

Fantastic Landscape, 45
Treetrunks, 45
Bark, 46
Foliage, 46
Rocks, 46

9. Portrait and Figure Painting, 51

Preliminary Drawing, 51
Head Study, 51
Figure Study, 53

10. Mural Painting, 54

Brushes, 54
Preparation, 54
Premix Your Colors, 55
Light and Shade, 55
Line, 55

11. Mixed Technique: Oil Colors on Acrylic Underpainting, 106

Painting Knife, 106
Acrylic Underpainting, 106
Support, 106
Mix Colors with White, 106
Scumbles, 107
Impasto, 107
Palette, 107
Oil Color Conditioners, 107
Preparing Acrylic Surface for Oils, 108

12. Landscape Painting in Mixed Technique, 109

First Underpainting, 109
Second Underpainting, 109

Applying Oil Color, 109
Deciduous and Evergreen Trees, 110
Treetrunks, 110
Rock Formations, 110

13. Still Life in Mixed Technique, 115

Wood Grain, 115
Glazes, 115
Opaque Colors, 116
Glazes and Opaque Color, 117
Transparent Color, 117
Highlights, 118
Brilliant Color, 118

14. Figure and Portrait in Mixed Technique, 136

Flesh Tones in Shadow, 136
Underpainting Flesh, 136
Overpainting Flesh, 136
Modeling, 137
Contour, 137
Glaze and Opaque Color in Figure Painting, 137

Conclusion, 141

Index, 142

FOREWORD

Treatises on the use of acrylic paints are numerous. The reason for the popularity of this new medium lies in the fact that acrylic colors lend themselves particularly well to covering very large surfaces in the manner generally referred to as *avant garde*. As my readers may know, I have consistently resisted the pressure to follow fashionable — but transitory — trends in the firm conviction that enduring art can be built only on traditional premises.

The principles of poor and of noble pictorial treatments have hardly changed in the course of time. Whatever the medium, the application of paint can be either skillful or clumsy; it can be indifferent, like wall painting, or it can possess the sensuousness of rich fabrics — just consider El Greco, Rembrandt, Goya.

Acrylics are decidedly a non-traditional material. How can we relate this medium and its technique to systems of painting that we find in Giotto, the van Eycks, the Brueghel-Rubens school, the masters of the late Renaissance such as Titian or, finally, El Greco? In these varied examples, we witness every conceivable painting technique. Hence, it would seem that we are free to select from the cornucopia of techniques to find the one that best suits our aims in acrylic painting.

But all these masters, with the exception of Giotto, used oil colors. To what extent can we follow the precepts of these great masters when we use modern acrylics? The answer will be found on the following pages.

ACRYLIC PAINTING FOR THE BEGINNER

1/THE NATURE OF ACRYLICS

For most painters, the world of chemistry represents an inaccessible territory which should be left to the specialist. At our present stage of technological knowledge in science, such trust appears to be justified, although some of us remember that hardly half a century ago alchemy and quackery still prevailed in some branches of paint chemistry.

Permanence

It is no exaggeration to say that acrylics have been well explored and that their practical imperishability is scientifically established. Of course, we must keep in mind that laboratory methods are one thing and the test exerted by time is another. Perhaps in a hundred years we will be able to declare acrylics absolutely permanent with even greater authority; but even a hundred years may not be enough to draw definite conclusions about the imperishability of any synthetic substance that we use for painting. Nonetheless, every reasonable scientific test indicates the extraordinary durability of acrylic paints.

But what is this substance? It is a plastic (synthetic) resin whose considerable flexibility does not seem to decrease with age. It is also non-yellowing and possesses great light refracting power. We have known acrylics for quite some time in the form of Lucite and Plexiglas. The reassuring thing is that this resin is used in the new industrial water-based paints, and these have proven their toughness under very severe outdoor conditions.

Chemical Behavior

The resin, suspended in the form of very fine particles in water to form an emulsion, is the binder or vehicle compounded with the pigments. It is also our painting medium (that is, our paint thinner), as well as our varnish. As it comes from the tube, acrylic paint (that is, pigment compounded with medium) can be extended with water to a very large degree without losing its binding or adhesive capacity. Once dry, acrylic paint becomes water-insoluble, however, and must (if necessary) be removed with benzine or lacquer thinner.

The mysterious term *emulsion* indicates the suspension of fine particles of one insoluble substance in another: in this case, a suspension of soft, plastic (acrylic) resin particles in water, in which they are insoluble. At this stage, the emulsion is a simple, unpolymerized compound having low molecular weight. This acrylic *monomer* is suspended in water by stirring, along with protective colloids or other

emulsion agents that help to keep the emulsion intact. Then a catalyst is added that causes the monomer droplets to polymerize into a resin, or *polymer,* and the finished *acrylic polymer emulsion* is achieved. In short, a simple molecule is transformed into a more complex molecule that makes a tougher film when dry.

When the emulsion (or water suspension of insoluble resin particles) dries as the water evaporates, the plastic resin particles come closer together until they touch each other and flow into a sturdy, flexible, coherent film. In this type of film formation, there are still fine microscopic holes, like pores, and this is why the film is permeable by (but not soluble in) water. That is, if the emulsion dries on a nonporous surface (such as glass, steel, acetate, film, or an oily coat) the film cannot embed itself in the irregularities of the surface; when the coated object is soaked in water, the film will strip off because water gets through the film and behind it. However, on wood, masonry, properly prepared canvas, or a roughened, non-oily surface, this film retains exceptional adhesion.

2/MATERIALS AND EQUIPMENT

In this treatise, I am concerned only with representational painting, as I have said. Hence, all implements used will be of the traditional variety. This is in contrast to abstract modes of painting, where no limits are set on tools and materials capable of producing bizarre or startling effects.

Support

To begin, which is preferable, an elastic or a rigid support? Since acrylic paint possesses sufficient elasticity to be applied on canvas, the painter may use either stretched canvas or a panel.

In choosing between linen and cotton canvas, we should be guided by the nature of the weave's particular texture, for there is no distinction between cotton and linen as regards durability. The tensile strength of linen is greater, but this is immaterial when the fabric is used for painting pictures. On the other hand, cotton is less hygroscopic — less apt to absorb moisture — hence, less subject to contraction and expansion due to atmospheric moisture.

Because the relatively flat, fluid nature of acrylic colors does not favor marked execution of textures — unless we use modeling paste, which is primarily for working in a nonobjective manner — we should carefully consider the textural nature of any elastic support we choose for our work.

In Fig. 1, a raw canvas was coated with acrylic gesso much more heavily on the right side than on the left. If we were using oil paints, we would decidedly prefer the rougher texture. But, for acrylics, the fabric must be largely deprived of its tooth, else the brushstrokes, settling in the interstices of the canvas, will fail to register properly. Because a relatively smooth texture is preferable, we could say that, as a rule, a panel will be the more suitable support for acrylic painting.

As for ready prepared canvas, this is suitable for acrylic painting provided that the commercial canvas carries an acrylic (not oil) ground and that the paints are used as they come from the tube or thinned with acrylic medium. If the colors are thinned with water, their adhesion to the support may not be sufficient.

But those who do not shun additional labor will prefer to prepare the raw canvas themselves.

Stretching a Canvas

First, cut the raw or ready-made canvas 1" larger all around than the rectangle formed by the stretchers, making sure that these are aligned at right angles.

Next, tack the canvas in the middle of one bar (using 3/8'' upholstery tacks), pull the fabric as strongly as you can to one side, then tack it at the end of the same bar. Do the same at the opposite end of the bar. Now you may hammer in all the tacks needed on that bar, spacing them about 1½'' apart. Do the same to the opposite (that is, parallel) stretcher bar, but here you must also pull the canvas toward you whenever you drive in the tack. On the two remaining bars, the canvas should be pulled toward you as you nail it down. At the corners, the canvas should be folded as illustrated in Fig. 2.

A word of warning: the canvas covered panels so popular nowadays are not sympathetic to the touch of the brush or the knife. They are a handicap rather than an advantage in painting. Hence, their use is not recommended.

Priming a Canvas

For priming a canvas, acrylic gesso should be used as it comes from the can. First, a utility brush (2'' - 4'' wide) should be dipped slightly into the gesso and drawn without undue pressure over the surface of the canvas, not forcing the material through the fibers to the reverse side. When saturated with gesso through and through, the canvas becomes stiff, thus losing the advantage of its flexibility.

When the first layer is dry, the next layer of gesso should be applied with the spatula as seen in Fig. 3. Upon drying, examine the surface for roughness and, if needed, sandpaper it. How many more applications of gesso will be needed depends on the smoothness or roughness of the fabric. If the declivities between the woof and the warp are shallow, two primings (always with the knife) will suffice. But in our case (as seen in Fig. 1), the portion to the right received one application with the brush and two with the knife; on the portion to the left, four additional layers were needed to make it suitable for acrylic painting.

Now you may ask: why do we use the brush first and then the knife? As you will experience, the gesso must be forced between the fibers with marked pressure, but without soaking through; if we should do this on the raw fabric, the priming would penetrate to the reverse side.

After the traditional priming used for oil painting (glue size applied to the raw fabric), the canvas does not lose its tautness. But when acrylic gesso is used, the canvas becomes slack. Therefore, after the first acrylic priming, wooden keys (which come with the wooden stretcher bars) should be inserted into the slots in the stretcher bars. There are two of these in each corner; by gently hammering the keys in, one can render the canvas taut again. Tacks should be placed in front of the keys to secure them (Fig. 4).

It is also a good practice to insert a piece of cardboard between the stretcher bar and the canvas when you are priming these areas. This will prevent creases that may form when the spatula presses against the inner edge of the stretcher.

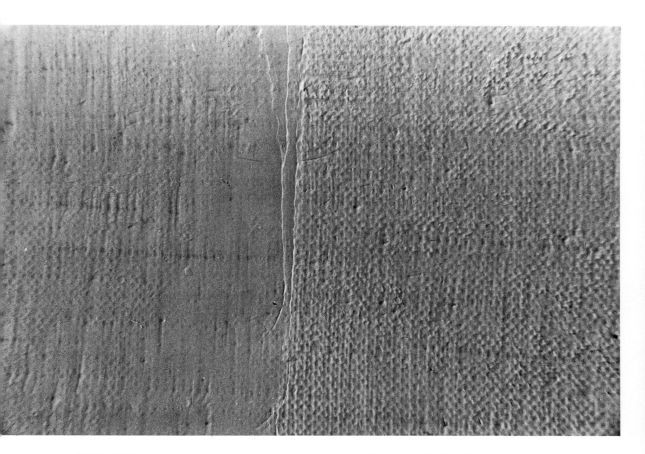

Figure 1: This moderately rough, densely woven linen was first primed lightly with a brush; then it was sanded and primed again, this time with a spatula. Using a spatula is important, because only a knife is capable of pressing the gesso into the interstices of the fabric. The left side of the canvas received two applications of gesso; the right side received three applications. However, even a fourth priming might be desirable on coarse fabric.

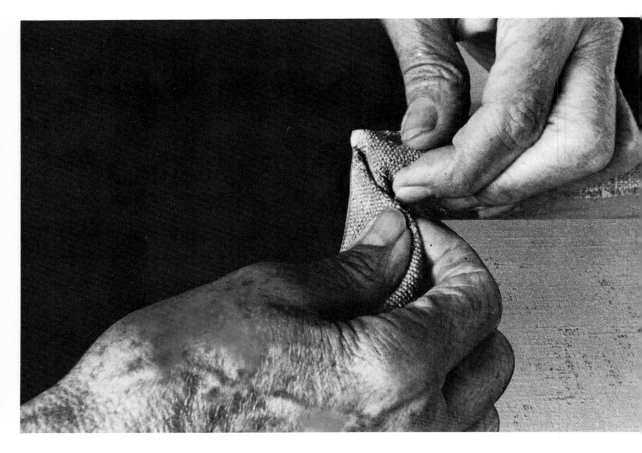

Figure 2: The canvas is folded at the corners of the stretcher bars.

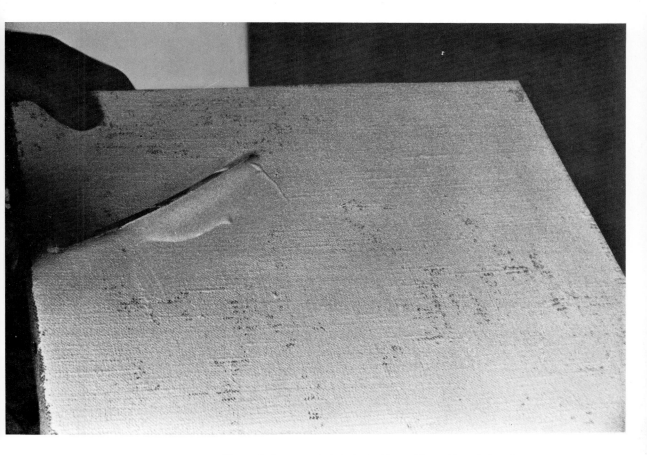

Figure 3: The spatula is held in this position while priming the canvas.

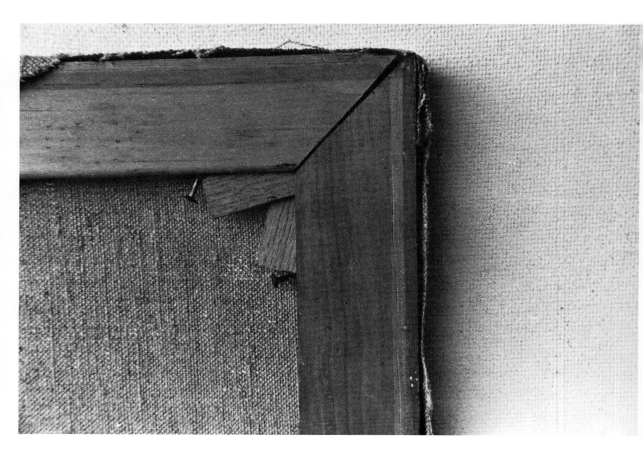

Figure 4: To make the canvas taut, keys are placed in the slots provided for them at the end of each stretcher bar. The key nearest the canvas is hammered in first. Should the canvas remain slack, the key on the adjoining bar can be hammered in. The keys can be secured by driving tacks in front of them.

Priming a Panel

Untempered Masonite, 1/8" thick, will be our choice for panels. Because of esthetic — not technical — considerations, only the smooth side should be used; the rough side resists fluent and sensitive brushwork. According to my own experience and that of my students, such panels never need sanding. The adhesion of the gesso is always perfect.

As I have mentioned, acrylic gesso, when used in its original consistency straight from the can, leaves brushmarks on the panel's surface — a most undesirable effect! Therefore, it should be thinned to the consistency of milk. To make the priming sufficiently opaque, three applications of the thinned gesso solution will be required. These applications of gesso should always follow one another on a perfectly dry surface, each coat brushed at right angles to the preceding one. The finished surface should not be sanded! After this procedure, the panel is ready for painting.

Small panels, up to about 12" x 16", do not require counterpriming as a rule; that is, they do not need gesso on the back. But the larger sizes of Masonite (as well as cardboard) should also be primed on the reverse side to prevent warping. Should it become warped, a Masonite panel cannot be made straight again unless it is glued to a supporting framework of wooden bars.

Ready-prepared gesso panels can also be obtained in art supply stores, but I find their mechanically smooth surface disagreeable to use. In commercial production, the gesso is sprayed onto the panels, and sometimes even polished to perfect smoothness.

Cardboard and Illustration Board

Sturdy cardboard or illustration board is an excellent material for use with acrylics and, if it is of good quality, we may use it without hesitation. Even inferior boards, when surfaced with acrylic gesso, will acquire a durable finish; when glued to a panel, their toughness is quite satisfactory. The cardboard panel should always be counterprimed to prevent warping, and its surface should be neither too smooth nor too rough.

A slightly pebbly surface is best, for, unlike a smooth finish, it will allow us to use the spatula for priming. Two or three primings of *undiluted* acrylic gesso will be all that is needed to produce a satisfactory surface. Only the spatula should be used for this operation, because as long as there is a certain surface graininess, the knife can force the priming material into the grain. When used for priming a perfectly smooth surface (such as we find on a Masonite panel), the thick gesso slides over the surface, finding "no place to go," and forms ungainly ridges, which are quite difficult to eliminate.

Of course, a smooth board should be primed with a utility brush and thinner gesso, following the instructions given for Masonite. Always prime *both* sides to prevent warping.

Paper

Paper is also a logical support for acrylic painting, as long as the technique retains the character of watercolor or gouache (opaque watercolor). This is not to say that a very thick painting would not behave well on paper, but the physical manipulation of heavy paint would be difficult on such a support.

As a rule, paper has a texture of its own, and its choice must be left to the painter. But it should be said that excessively smooth or rough surfaces should be avoided. Paper of normal absorbency need not be primed. When you are painting with acrylics, even medium weight paper does not tend to wrinkle as much as it does in watercolor painting. When permanence is important, the paper should possess a high rag content.

Other Supports

Acrylic paints, now almost universally used in house painting because of their remarkable adhesion, can be applied to literally any non-oily support — including composition boards of every description, stone, metal, glass — without any prior preparation. However, as I have said, surfaces with some moderate texture and absorbency — rather than glassy surfaces — are best for permanent adhesion.

When painting on plaster walls in the so-called *fresco secco* technique, we may wish to isolate a surface which is too absorbent. This will be discussed later.

Bristle Brushes

When one uses acrylics, bristle brushes can be just as important as soft hair brushes, though both can be used.

Bristle brushes come in *flats* and *brights* (Fig. 5). The first have long bristles and the second have short bristles. For painting with the salve-like acrylics, the long bristled flats are decidedly better for proper distribution of paint. When used with paint that is thinned with medium and/or water, these brushes will not leave undue marks, especially on grainy surfaces. Now it must be understood that a "loaded" brushstroke, so important in oil painting, cannot be used efficiently in acrylics (I am referring, of course, to traditional painting); even on nonabsorbent surfaces, heavy paint becomes solid and immovable in short order (in a matter of minutes) and its manipulation becomes impossible.

Another category of bristle brush is the one seen in Fig. 6. This is the *round,* the only brush logically constructed to be used in mural painting. The bristles are set in a round ferrule, giving this tool the greatest possible mobility, which the standard flat bristle brushes do not possess. Useful, also, in painting on canvas or on panels, its marks do not differ from those of a large round sable brush, and the tough bristles are capable of coping with the roughness of a wall surface when painting murals.

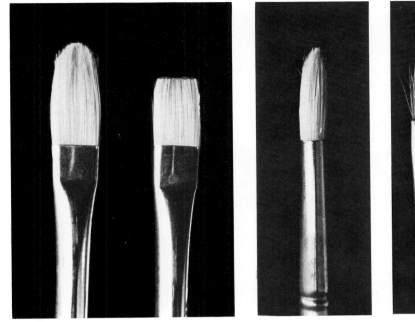

Figure 5: Bristle brushes come in kinds referred to as "flats" (left) and "brights" (right).

Figure 6: A round bristle brush, excellent for mural painting.

Figure 7: A flat sable brush.

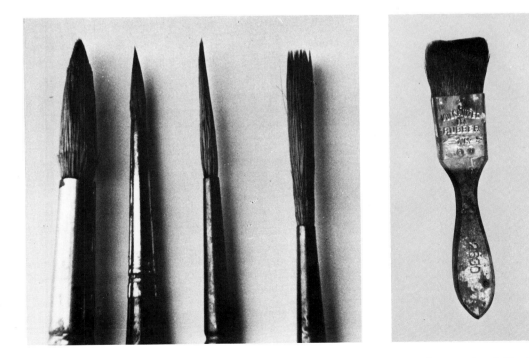

Figure 8: A collection of round sable brushes. The last two on the right are a scriptliner and a striper.

Figure 9: The soft hair blender is used in blending oil colors over an acrylic underpainting.

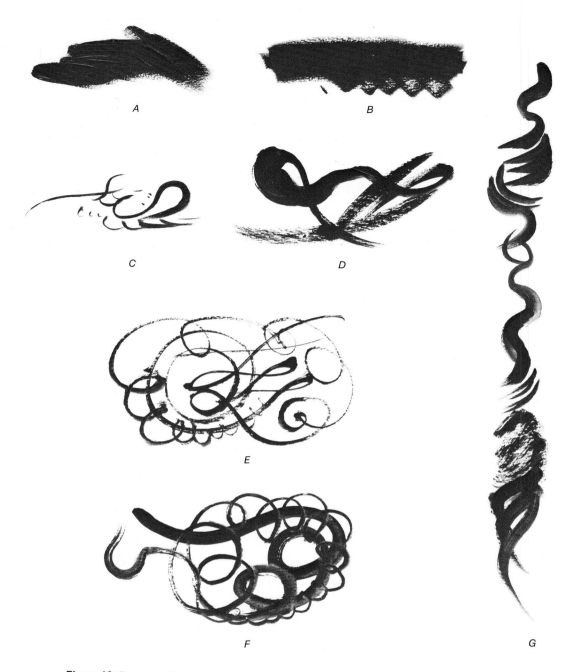

Figure 10: The mark illustrated in example *A* was made by a bristle brush carrying enough paint to leave a definite impasto. Acrylic impasti do not blend well; their fusion is imperfect. Moreover, they are not texturally attractive. Of course, bristle brushes are also capable of leaving smooth surfaces if the paint is sufficiently thinned. The solid surface in *B* was produced with a flat sable brush without undue grooving. The marks in *C* were made with a small round sable brush; those in *D* were made with a large round sable brush. Both small and large sable brushes make precise marks, but they must frequently be reloaded with paint, because they do not take up enough paint at one time to keep them charged for long. Also, the paint should be liquid or semiliquid. For the scriptliner and the striper *(E and F)*, an even higher degree of liquidity is required in the paint. These brushes will hold a very considerable amount of paint, however. In fact, the curlicues illustrated here were made in one operation. In *G,* a round bristle brush was used. These marks do not differ from those made by the round sable brushes, except that they allow greater vigor and can produce a firmer mark.

Sable Brushes

Next, let us consider the typical brushes that are especially adapted for work with semiliquid and liquid paint. These are made of sable hair, a lesser quality hair such as fitch, or the substitute (of more recent date) known as sabelene. Two distinct categories of these brushes are available — the *flat* (Fig. 7) and the *round* sable brush (Fig. 8). The round brushes appear with a head of "normally" proportioned hair and also with extra long hair. This very long hair can terminate either in a fine point, in which case we speak of a *scriptliner*, or it may end with a chisel shape, and such a brush is called a *striper*.

The marks left by all these brushes are distinctly different (Fig. 10): those made with a bristle brush (A) are in marked contrast to those made with a flat sable brush (B), which are smooth, and lack the parallel grooves left by the much stiffer bristles. Round sable brushes are designed for more deliberate work where a precise stroke and clarity of definition are required (C, D). In portraiture, for example, only these brushes would serve the purpose, whereas in landscape, still life, or larger figure work, a scriptliner (E) or a striper (F) would produce much freer, more undulating effects. Finally, the marks of a round bristle brush are seen in G.

When you are working with the brushes, it will be necessary to keep them continuously moist, else the paint will dry on them in a matter of minutes and will be difficult to remove. It must be stated, however, that keeping the brushes in water will make them soggy — an unpleasant but unavoidable drawback!

Soft Hair Blender

Lastly, the so-called *soft hair blender* should be mentioned (Fig. 9). It is made of squirrel hair and its use is limited to occasions when a perfect blending of oil colors, applied to an underpainting in acrylics, appears to be desirable.

Painting Knife

As to the painting knife — an instrument as important in oil painting as the brushes — in acrylic painting its use is limited. The use of the knife is always a problem when you are working on a rigid surface, because such a surface does not respond well to the striking of the knife. Moreover, acrylic paint dries so rapidly that its free manipulation with the knife is greatly impaired.

At any rate, when a knife *is* used, it must be properly constructed: stiff at the handle end and quite elastic over the length of 2" to 4".

3/DILUENTS, VARNISHES, AND SOLVENTS

Acrylic paints can be diluted with water to a very large extent without losing their cohesion. And when you are painting in a watercolor technique on paper, this dilution can be carried out to any desired degree.

Acrylic Medium

When you are working on a nonabsorbent ground, rather than on paper, it is advisable to add acrylic medium to the water used for thinning; this will render the paint more adhesive. The medium dries rapidly, so the brushes should *always* be kept in a jar of clear water when not at work, even if you pause for only a few minutes.

Abundant use of the medium produces a moderate gloss, but if an entirely flat effect is desired, you can get it by using only water. When you are working on a largely nonabsorbent surface, excessive dilution is not advisable. You can also use a matte acrylic medium for thinning; in mural painting this becomes the logical medium to use.

Acrylic Gel

Still greater adhesion of acrylic colors can be obtained by using acrylic gel, an adhesive of salve-like consistency. This is recommended by the manufacturers to thicken paint and produce "impasto glazes." The latter is a contradiction in terms, for glazes and impasti are at cross purposes; glazes are most effective when applied thinly. But for collage-makers and nonobjective practitioners, this adhesive and thickener will serve its purpose well.

Acrylic Varnish

Acrylic varnish is nothing more than acrylic medium which produces an adequate gloss on a painting; a matte acrylic varnish can be used for satiny finishes.

Acrylic paintings can be varnished as soon as they are dry, which is often a matter of minutes. Once dry, clean acrylic paintings with mild soap and water.

Paint Removers

Dried paint can best be removed from the palette or from brushes with a paint remover or a lacquer thinner. These can be bought in your local paint or hardware

store. Manufacturers of acrylic paints also produce solvents made specifically for use with their own products.

However, it is best to avoid this problem altogether by always working with a wet brush and never allowing paint to dry on the bristles. Nor will you have to use a solvent to clean your palette if it is made of glass, metal, plastic, or enamel; a simple soaking in water should allow you to peel off the dry color.

4/COLORS

Acrylic colors are obtainable either in jars or in tubes. The colors in jars have a thick, liquid consistency and are particularly useful in painting large surfaces, such as murals. The tube colors have a creamy consistency; when brushed on undiluted, they retain the shape and texture produced at the moment of application.

Tube and jar colors do not differ in regard to drying time; in a room temperature of 70° F., glazes and slight impasti will dry on an absorbent surface in a matter of a few minutes. Moderately high impasti will also become immovable in short order, but paint heaped up on the palette will remain in usable condition for a much longer time.

In other words, the bigger (that is, thicker) the mass of paint, the longer it will remain moist. In actual painting, however, this is of no consequence, because the nature of acrylics does not invite high impasti, for technical, as well as esthetic, reasons.

Preparation

Acrylic colors can be effortlessly prepared by combining dry pigments with acrylic medium. In this case, grinding with a muller on a carborundum-roughened glass plate, as is customary in oil painting, is not required. The particle conglomerates of the pigments disperse easily in the medium when rubbed in with a spatula. Such paint will be quite thin, and is especially good for mural painting. It can also be stored in well-closed jars, where it will remain in a usable condition for a long period of time. It is very important for anyone who sets out to paint with acrylics to know these characteristics, because the procedures are quite different from those used in oil painting.

List of Colors

It is always a good practice to limit one's colors to a narrow range and to achieve all desired color effects by working within this palette. It is deceptive to assume that an overabundance of different colors enriches one's palette. The following list should allow the painter to treat any conceivable subject matter with complete freedom.

Note that certain pigments used in oil painting cannot be advantageously combined with acrylic medium in the manufacture of artists' colors; hence the omission of these popular colors from our list: flake white, viridian green, Prussian blue, ivory black, and alizarin crimson. But their equivalents, or near equivalents, will satisfy all requirements.

White: titanium white

Blue: phthalo blue (short for phthalocyanine blue), ultramarine blue

Green: phthalo green (short for phthalocyanine green), chromium oxide green

Yellow: yellow oxide, cadmium yellow light (and cadmium yellow medium, if desired)

Orange: cadmium orange

Red: red oxide, cadmium red light (and cadmium red medium, if desired)

Brown: raw and burnt sienna, raw and burnt umber

Black: Mars black

Purple: acra violet

Additional colors for those with voracious coloristic appetites are listed below.

Blue: cobalt blue

Yellow: Hansa yellow

Red: acra red; naphthol ITR red and crimson

Placing Colors on the Palette

For efficiency, it is practical to place the white between the warm and the cool colors. Since the blues and greens (the cool colors) are not as numerous as the warm colors (the yellows and reds) it is best to place white next to the cup of medium at the right side of the palette. It is also logical to start with the lighter colors and proceed to the darker. All colors should be placed near the edge of the palette to leave as much free space for mixing as possible.

Because it is necessary to remove the dried paint from the palette daily, it is advisable to place the colors on a surface made of a plastic, glass, or hard enamel, from which dried color can be stripped after soaking in water.

Characteristics of Colors

White: Titanium white is the strongest of all the white colors; a little goes a long way. But because all the other acrylic colors possess good tinting capacity, they can cope with it.

Blue: Phthalo blue is "neutral." That is, unlike ultramarine blue, it is free from any purple tinge, and also from the greenish cast of Prussian blue. In mixtures with white, it produces a pure, "celestial" blue, comparable to ancient lapis lazuli.

Green: Phthalo green, which substitutes for the viridian green of our oil color palette, is also much stronger in hue and tinting power, and its color is rather acid.

Chromium oxide green is an inordinately dull color — which does *not* mean that this quality is a disadvantage; a dull green can be useful.

Yellow: Yellow oxide is another name for our old standby, yellow ochre. However, it is not the lightest, most low-keyed on our palette. This would be Naples yellow. Thus, in the absence of Naples yellow, we shall have to mix yellow oxide with white. Cadmium yellow, on the other hand, is our brassiest, most aggressive yellow, and in flower painting, for example, we would wish to have both its lighter and darker variety.

Orange: Those intent upon limiting their palette may simply mix cadmium yellow and cadmium red to produce cadmium orange.

Red: Red oxide is identical with Venetian red, a bright, brick red, and cadmium red is the one fiery red on our list. The addition of acra violet (identical to alizarin crimson oil color) to cadmium red will darken its hue without changing its intrinsic character.

Brown: The lightest yellow-brown is raw sienna; burnt sienna is darker and reddish in color. Raw umber is a duller and still darker brown, and burnt umber is our darkest warm red-brown.

Black: Mars black is our darkest color and has greater tinting and hiding power than the ivory black used in oil painting.

Notes on Color Mixtures

In the following list, I shall describe some useful intermixtures of colors.

White: White, when mixed with other colors, will reduce their strength to pastel hues; with some, it will radically alter their color value. This is demonstrated on our color chart (p. 57).

Blues: Blue is a primary color; it cannot be obtained through an intermixture. However, phthalo blue and ultramarine blue will only on rare occasions be used as they come from the tube. As a rule, all blues have to be mixed with some white.

Greens: Phthalo green yields the strongest green hues when mixed with cadmium yellow. Ultramarine and phthalo blue will also produce strong greens when mixed with cadmium yellow. Similar color values can be obtained by mixing chromium oxide green with cadmium yellow. A variety of darker greens will call for mixtures of phthalo green and yellow oxide, raw sienna, or cadmium orange. Mixed just with white, phthalo green becomes a pale, bluish green. Strong greens can also be mixed from black or umber with cadmium yellow.

Yellows and Reds: These are also primary colors. They cannot be produced through intermixtures of other colors. All the yellows will become lighter, without losing their intrinsic character, when white is added. But the reds (also burnt sienna)

will turn pink when mixed with white. Mixed with blues, they will appear dark purple. When white is added, mauve will result.

Acra violet: This is a color which we would designate as purple; when combined with ultramarine blue and white, it turns an intense violet.

Browns: Raw sienna (like yellow oxide) will lighten the hue of umber and burnt sienna. White added to umber (raw or burnt) will produce a variety of brownish grays.

Grays: The first combination that comes to mind is black and white. But such grays are rather monotonous. A much more varied range of cool and warm grays can be obtained by mixing either one of our blues with the umbers and white. Without white, this combination will yield a deep black.

5/GLAZES, WATERCOLOR AND GOUACHE TECHNIQUES

A glaze is a transparent color. To act transparent, the glaze — whatever its color — must rest on a lighter surface. The lighter the glaze, the lighter its underlying color must be. Thus, glazes produced with yellow oxide, raw sienna, or cadmium yellow should be, for all practical purposes, applied only to white surfaces. A glaze of a dark color, however, will register equally well on an off-white, grayish, greenish, yellowish, or pink underpainting. A yellow underpainting, more than any other color (except white), will endow a glaze with the greatest luminosity.

Diluting Glazes

Diluting glazes depends on the strength of the glaze, that is, on the degree to which the particular color is diluted by acrylic medium or water. When the color is thinned with water alone, the glaze will appear flat and its color dull. If acrylic medium is used, the glaze will dry to a semigloss or glossy surface, depending on the absorbency of the priming; its color will also be deeper. But a glaze that appears dull can be brought up to its full color value when varnished with acrylic medium or varnish. It can attain a still greater luminosity when overpainted with oil colors.

In oil painting, only certain colors are suitable for glazing. Those are primarily the ones that are transparent by nature, or that yield a useful color when greatly thinned. This is not the case with acrylic colors, any one of which can be thinned with water or medium to serve as a glaze. Because of technical reasons, only one glaze, or in rare instances the superimposition of two, is feasible in oil painting. But in acrylics, glazes can be applied in several layers before they begin to turn opaque.

Supports for Glazing

In glazing, a very important consideration is the nature of the support — its smoothness or roughness. On a coarse, open-grained canvas, glazes will prove to be ineffective. Also, underlying impasti (thick passages) produced with the brush will rarely enhance the appearance of a glaze, except in cases where a special "pebbly" surface is provided for them. Such impasti may suggest the textural roughness of specific objects, such as rocks, masonry, bricks, and the like. Because of these considerations, painting in glazes should be done — as a rule — on predominantly smooth surfaces, the best of which is provided by a panel which has been covered with gesso.

Various glazing applications are seen on p. 73. Those in the top row are the most commonly used on a white surface. They are (from left to right) burnt sienna,

phthalo green and blue, and burnt umber. In those in the second row, the color of the underpainting is cadmium yellow, glazed (from left to right) with phthalo green, cadmium red, and burnt umber. The color of the underpainting of those in the third row is pink — (cadmium red and white); they are glazed with phthalo green, acra violet, and burnt sienna. The impasto at the bottom was glazed with burnt sienna and phthalo green.

Multiple Glazes

Superimposition of multiple glazes is not represented on the chart on p. 00, because color effects cannot be reproduced in printer's ink with any degree of clarity. When you use a combination of glazes, you should always observe the principle of superimposing a darker on top of a lighter glaze. You should also remember that excessive thinning of the paint with water will deprive the pigment of its binder. Therefore, if you dilute your glazes to a great degree, the thinner should be either water mixed with acrylic medium or undiluted medium. Because of its stickiness, it is not always agreeable to use undiluted medium; as we know, the medium is really an adhesive.

Although you may not use an abundance of glazes in painting on canvas, you will often use them extensively when painting on panels, using oil colors for the overpainting (see Chapter 11).

Watercolor Technique

What is the difference between traditional watercolors and acrylic paints when you use only water as the diluent and employ a pure watercolor technique? First, acrylics can yield more strident hues; second, when dry, they are water-insoluble. These characteristics are not always advantageous; brilliance is not invariably called for in traditional watercolors, which depend, as a rule, on tonal values. Moreover, in acrylics, it must be considered that corrections (washing out) of dried color are not feasible.

There are two standard kinds of watercolor: those in the form of hard cakes (round or square) and the soft tube color (also sold in semihard cakes). The first contain only gum arabic as a binder; the second are prepared with a considerable quantity of glycerin, therefore they remain in a semimoist condition for quite some time. Furthermore, when dried on the palette, acrylic paint becomes useless, whereas traditional watercolor can be dissolved again in water at any time.

A great advantage of acrylics is that even 140 lb. paper (relatively thin) will not wrinkle or cockle unduly when wetted with the medium, so it need not be taped to the drawing board when working on it. Simply tack it down securely.

Finally, there remains this question: which material — traditional watercolor or "acrylic watercolor" — accounts for more satisfying results when we consider a picture's esthetic appeal? Are the more brilliant, high-keyed colors more desirable than those that provide muted tonalities? There can only be one answer to this

problem: it all depends on the chosen subject matter — certain motifs call for intense coloristic effects, others for harmonious tonalities. In the final analysis, the painter's own taste must be the deciding factor.

Gouache and Casein Techniques

These are nothing more than opaque watercolor: that is, any watercolor mixed with white for light effects. Traditionally, painting with casein colors is done on white paper, but gouache employs tinted papers as a support. The reason for this is that every one of the gouache colors is cut with white by the manufacturer. This is technically correct, but it does not allow deep, dark, velvety tones.

Since the advent of acrylics, however, these materials have become obsolete. For example, when you use tinted papers for painting, the hiding capacity of the paint is of great importance; in this area, the superiority of acrylics over traditional gouache and casein becomes quite marked.

6/SCUMBLING AND OPAQUE PAINTING

A scumble is just the opposite of a glaze: it is the application of a lighter on top of a darker color in a manner that allows this dark color to assert itself faintly. The scumble must be semiopaque, and to achieve this, the paint used for this purpose must be diluted to a certain degree, but never to the consistency of a glaze.

Notes on Technique of Scumbling

A typical example of a scumble is used, for example, in painting white clouds into a darker sky in a semitransparent fashion. Whereas it is feasible to apply several glazes one on top of the other, scumbling is an *alla prima* operation: you cannot build it up in stages, but must aim for the final effect from the beginning; once done, overpaints cannot be carried out on top of the scumble without nullifying its effect. The great hiding capacity of acrylic paints is *not* an advantage in scumbling, especially since the very powerful titanium white will enter practically every color except the lightest; hence, an acrylic scumble must be applied very thinly.

The use of scumbling in acrylics is much more frequent than glazing. The only handicap we shall encounter here is that, because of the rapid drying of acrylic paints, scumbling wet-in-wet is not possible, whereas in oil painting this procedure is almost always the rule. However, by dragging a semiwet brush over a dry surface, scumbling with acrylics can be quite effective, although lacking the mellowness of the scumbles produced with oil paint.

Some Examples of Scumbles

On p. 89, scumbling was carried out on three underpaintings: burnt umber, blue-gray (raw umber, phthalo blue, and white), and red oxide.

In the top row (the burnt umber underpainting), we see, in sequence, the following scumbles: yellow oxide, cadmium yellow, red oxide and white, and phthalo blue and white.

In the center row (the blue-gray underpainting), we see the following scumbles: white, pink (cadmium red and white), yellow (raw sienna and white), and purple (acra violet, white, and yellow oxide).

In the bottom row (the red oxide underpainting), we see the following scumbles: blue (ultramarine blue and white), green (phthalo green and cadmium yellow), purple (acra violet and white), and brown (raw umber and white).

Note that all colors used for scumbling were strongly diluted with acrylic medium.

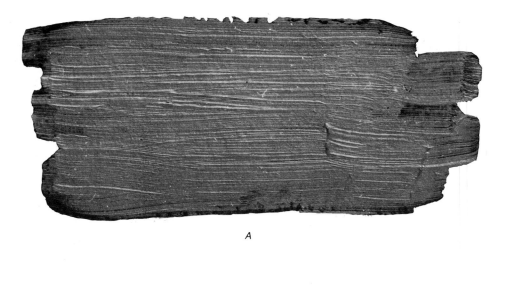

A

B

C

Gloss

Acrylic, if not diluted by water, dries with a faint gloss that increases if acrylic medium is used. More gloss can be produced by varnishing the surface with the same acrylic medium, thus significantly intensifying the depth of the colors and enhancing their tonality. As such, an acrylic painting may resemble one executed in oils, except that it will not show the fusion and blending of colors we know in traditional oil painting.

Opaque and Impasto Painting

Next to brilliance, the most outstanding characteristic of acrylic paints is their great opacity. This opacity allows complete and effortless overpainting; no matter how thin the paint (if undiluted), it will hide all underlying applications of color.

When you use acrylics, impasto painting — exploiting brushstrokes with a pronounced body — is not recommended. The reason for this is that the paint dries quickly and the accumulation of brushstrokes will form a disorganized mass (Fig. 11). On top (A), the 4" long brushstroke dried in a matter of minutes. The mark underneath (B), was made by a painting knife, and also became immovable in short order. On the bottom, you see an incongruous mass of two superimposed brushstrokes on top of a previously dried application (C). Such disorganized textures are never seen in works of competent painters.

Of course, it is quite conceivable that all the heavy brushstrokes in a painting might be produced as a one-phase operation. Van Gogh painted in the heaviest impasti, never overpainting or correcting once the paint dried. But using oil paints, he had ample time to redirect, reorganize, or amend his work. In acrylics, only moderate impasti, showing no appreciable thickness, are recommended.

Figure 11: Three examples of texture: the top example (A) shows deeply grooved brushstrokes made by a bristle brush; the center example (B) shows the texture produced by a painting knife; the bottom example (C) shows the superimposition of two layers of brushstrokes running in different directions.

7/STILL LIFE AND FLOWER PAINTING

Painting a still life involves several processes. In the still life painting entitled *Driftwood and Shells* these processes are presented in three stages (see demonstration on pp. 58-61).

Beginning a Still Life

A photograph of the motif of *Driftwood and Shells* is shown on p. 58 to give the student an idea of its original appearance and its metamorphosis into the final composition. It must be understood that the final arrangement does not have to be exactly like the original image. The arrangement can be altered in any conceivable manner, as long as the final appearance impresses you as authentic. However, we cannot depart too far from the original image, or the painting will become abstract or nonobjective.

Our drawing of *Driftwood and Shells* (p. 59) is realistic, but it is not carried out in detail. It also lacks the definitions of light and shade. The reasons for these omissions is that these details will be lost when covered by the first acrylic underpainting.

First Underpainting

The first underpainting of *Driftwood and Shells* was done on illustration board, which, in spite of three primings, retained a slightly pebbly surface. Because of this graininess, the ground was primed with a spatula. The following colors were used in the first underpainting: pink (red oxide and white) for the sky; umber, raw sienna, and white for the ground; raw and burnt umber for the driftwood; raw sienna and white for the small shell; and raw sienna, umber, and white for the large shell. Acrylic gesso was used as the white color. A bristle brush was used to rub the paint thinly into the surface.

Thus far, the steps for *Driftwood and Shells* follow a definite method. It must be understood that painting on a white ground without a preliminary underpainting is not the best practice; an underpainting is always preferable. What purpose does the first underpainting have, other than to cover the white canvas? The underpainting allows you to previsualize (to some extent) the final effects, to create the color relationships that help establish the final colors.

Let us examine the colors of the first underpainting of *Driftwood and Shells*. For the area of the sky, we have chosen pink. Since a predominantly blue color will be our final choice, pink will do well as a contrast; it will enhance the blue that is

painted thinly over it, endowing it with a luminosity that an opaque blue could not produce. For the driftwood, we chose a dark underpainting because the nuances of the final gray color could be worked in more easily over a dark ground. The rest of the painting's area was kept in a neutral brown-grayish color, also darker than the last color to be applied. It follows that scumbling and opacity will appear to be more appropriate than glazing in this case.

Second Underpainting

In the second underpainting of *Driftwood and Shells,* the upper part of the sky was lightened by a scumble of yellow oxide and white. The large shell was overpainted with cadmium yellow and white, and the small shell with white. The drawing of the objects was developed, improved, and strengthened with charcoal; it was then fixed with fixative.

In examining this stage, we see that certain changes will have to be made — changes that could not have been made before. The original idea will usually require modifications and rectifications. For example, the sky area at the top will eventually be lighter — hence, a color light enough to allow the superimposed light glaze to produce a lighter effect is used. The white underpainting of the small shell indicates that it will receive a glaze (in this instance, acra violet and black), and the bright color of the large shell indicates that its final color will be in a higher key. Finally, at this stage, the drawing is reestablished with as much accuracy as is needed to keep the nature of the objects clear.

The following colors were used for the final painting of *Driftwood and Shells:* phthalo blue, burnt sienna, and white for the sky, opaque in the lower part and very thin at the top. In spite of the thinness of this application, much of the yellow underneath disappeared — glazing in the acrylic medium does have its limitations! Hence, a yellow scumble (yellow oxide and white) was brushed over it. Raw and burnt umber, raw sienna, black, and white were used for the driftwood; yellow oxide, raw sienna, raw umber, and white for the ground; acra violet and black for the small shell; burnt umber, cadmium yellow, and white for the large shell. Thus, in all, seven colors and white (which was our acrylic gesso) were used. The paintings were thinned with 1/2 water, 1/2 acrylic medium.

Brushes

The following brushes were employed in *Driftwood and Shells:* one No. 7 bristle brush, one small sable brush, one round sable brush (a striper), and one scriptliner. All but the round sable brush were kept in water during the painting period. The scriptliner and striper, after their intermittent use, were washed clean. If kept in the receptacle containing water, the delicate body of the hair gets out of shape, and the brush fails to work properly.

It is advisable to heap the colors generously on the palette, or the supply will dry fast; small daubs of paint become unusable in a very short time. After the work is

done, the dried paint should be peeled off the palette after the palette has been soaked in water or it should be cleaned from the palette with a paint remover (see Chapter 3).

The Finished Painting

How does the finished acrylic painting differ from one executed in oils? It dries more or less flat, but an application of painting acrylic medium immediately after completion of the picture will remedy this. Evidence of glazes is minimal, scumbles prevail, and colors are blended not by fusion, but by dragging the brush. These, of course, are the limitations of this technique; the advantage is that one can stop painting and proceed with overpaints at any time and as often as desired. This, of course, is not possible when painting exclusively in oils, as they take much longer to dry than acrylic colors do.

Design

The battery of bottles shown in *Still Life with Bottles* (see demonstration on pp. 40-43) offers a new pictorial conception that is at variance with those seen elsewhere in this treatise. It is not the realistic aspect (see photograph on p. 40) of the object that is stressed here, but the appearance of the design (see preliminary drawing on p. 41). The actual *chiaroscuro* (ostensible relation of light and shade) is eliminated, and the emphasis is on the linear rather than pictorial aspect of the arrangement. Moreover, a certain amount of distortion enters into the conception of the objects for the sake of dramatization.

Open Color

A distortion of form will, in consequence, call for a distortion of color — for color and form are interdependent. One way to achieve a strong linear accent is to use what is known as the "open color" technique (see the underpainting of *Still Life with Bottles*). If the color of an object is not delimited by its contour, but enters the adjoining space, or if the adjoining space (or another object) imparts its own color to the neighboring object, a certain interpenetration occurs, allowing the design (which relies on outlines only) to prevail. In the final painting of *Still Life with Bottles,* the battery of objects was treated in open color; the design, stressing the linear, minimized the third dimension — the illusion of depth. The colors used in this composition included phthalo blue and green, yellow oxide, and cadmium red. White (again our acrylic gesso) was used here and there to reduce the high chromatic values of these colors. The contouring was made with colors used full strength.

The same ideas prevail in *Painter's Still Life* (see demonstration on pp. 62-64), except that, here, the objects represented were observed with greater faithfulness (see photograph on p. 62 and drawing on p. 63).

Flower Painting

Field Flowers (p. 67) was painted on a 12" x 9" gessoed panel. The area of the bouquet and the vase was stained with yellow (cadmium yellow and white), and that of the background with phthalo blue and white.

Underpainting Vegetation

Underpaintings of different objects will differ in color. However, when dealing with verdant matter, an underlying yellow will always prove to be of greater advantage than any other color. Of course, should the final overpaint of green color be applied opaquely, thus completely canceling the "life-giving" yellow underneath, we may say that such underpainting is pointless. Yet, we can never know in advance how much or how little of this yellow will reappear, and when it does, the liveliness of the green will become materially enhanced.

Background

The background of *Field Flowers* is a bluish underpainting, which was not applied in anticipation of a different subsequent color. It was painted first, so the motif could be painted on top, to avoid the "mending-in," of the background between the detached stems, flowers, and leaves. Such a mending-in, however, is seen in a few spots. It serves to allow the background to become visible, thus relieving the congested floral mass in the lower parts.

Materials and Techniques

The following acrylic colors were used in *Field Flowers* (in addition to white, which was our gesso solution): phthalo blue, cadmium yellow, cadmium orange, cadmium red, raw and burnt sienna, and acra violet — seven in all. The medium, as usual, was 1/2 water, 1/2 acrylic. The brushes were all sables — round, flat, and a scriptliner. The scriptliner was used exclusively where long, fine definitions were needed. In the area around the floral motif where the original background color is seen, the rendition was opaque. In a few instances, scumbling can be seen.

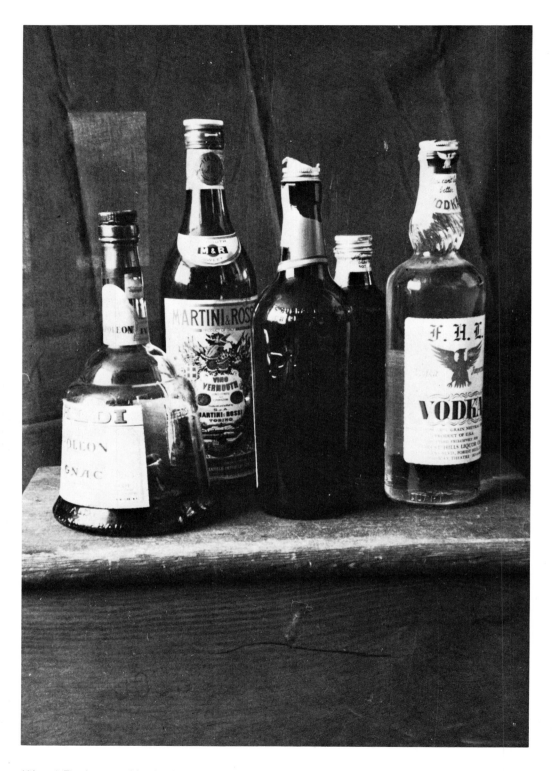

(Above) The battery of bottles in this photograph shows the starting point for a painting done in a semiabstract way, *Still Life with Bottles*.

(Right) **Still Life with Bottles** (Preliminary Sketch). The realistic element has been suppressed, and a certain amount of distortion can be seen in this sketch.

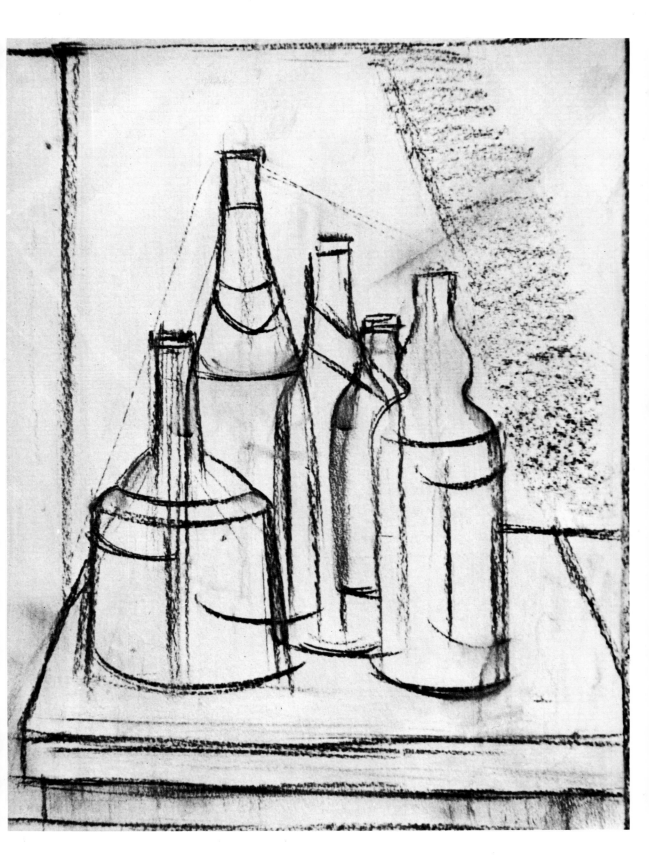

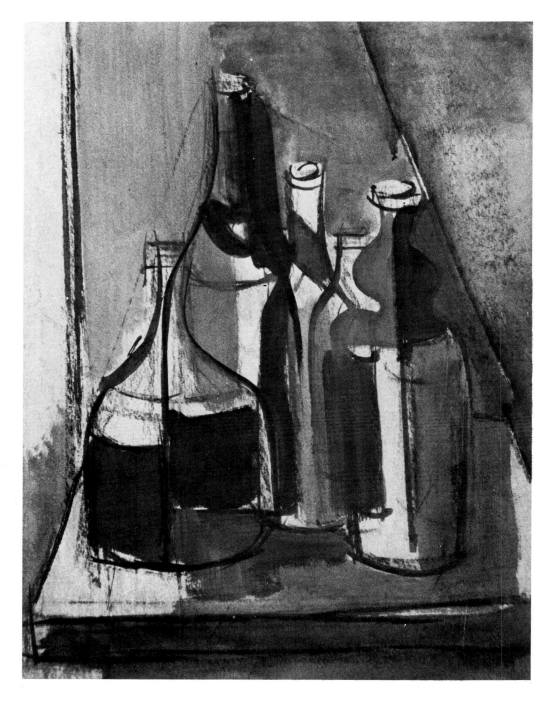

(Above) **Still Life with Bottles** (Underpainting). Distortion seen in the preliminary sketch is carried further. A strong linear accent is established by using the "open color" technique. The emphasis is on flat design, rather than on a three-dimensional, realistic rendition of the object.

(Right) **Still Life with Bottles** (Final Painting). "Open color" technique only was used for the final painting, stressing its linear quality and minimizing the illusion of depth. The acrylic colors used were phthalo blue and green, yellow oxide, and cadmium red. White (gesso) was used to reduce the strong chromatic values of these colors where necessary. The contouring was done with colors used full strength. In addition to round and flat bristle brushes, I used a scriptliner and a striper. Done on 25" × 18" board.

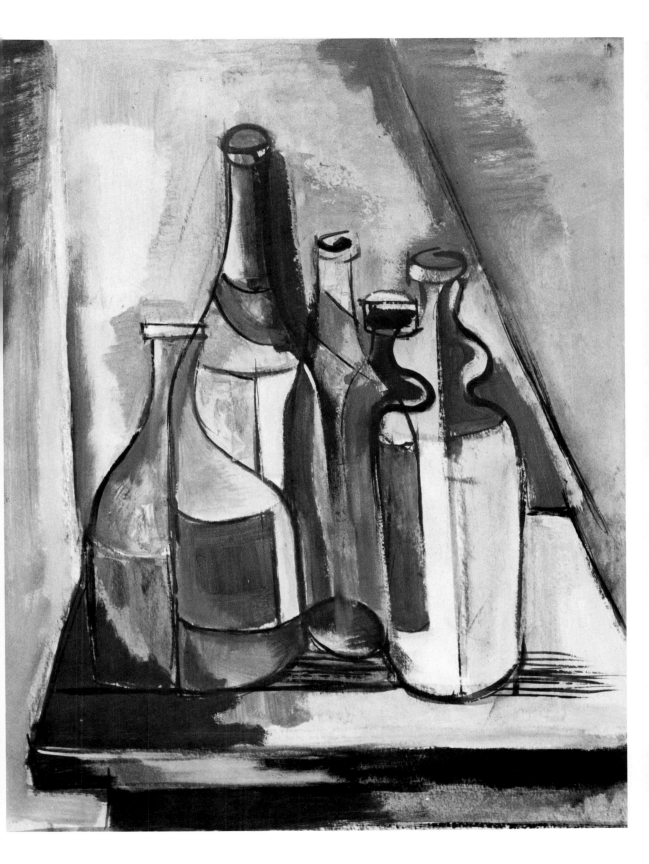

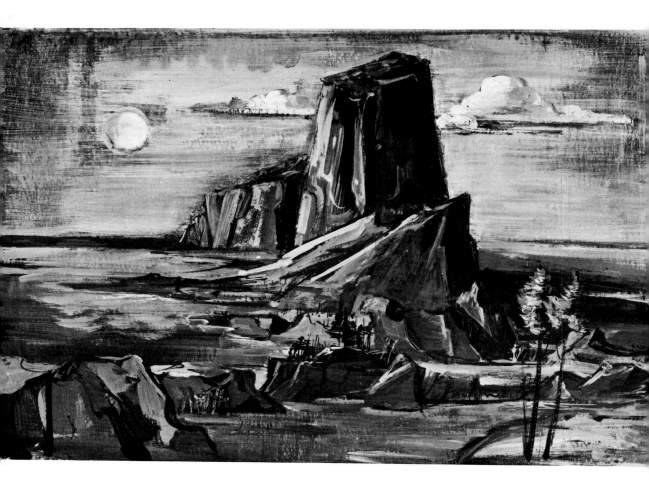

Fantastic Landscape. This painting was done on a 14" × 18" panel in predominantly opaque acrylic colors. First, a glaze of yellow oxide was spread over the entire panel. This glaze imparted a luminosity to the superimposed glaze of phthalo green and blue mixed with some yellow oxide. The rest of the painting is entirely opaque; it received many overpaints, each of which covered the underlying passage completely. In addition to a small round sable brush and two scriptliners of different sizes, I used a No. 6 bristle brush with just a little paint for scumbling. The colors used for the overpainting were phthalo blue and green, ultramarine blue, chromium oxide green, yellow oxide, cadmium yellow, raw sienna, raw umber, black, and white (gesso).

8/LANDSCAPE

When selecting subject matter, two principal characteristics should be kept in mind: first, what technique we should use; second, which of the existing styles our talent responds to more readily.

Fantastic Landscape

Our example, *Fantastic Landscape* (left), was done in predominantly opaque acrylics. My aim was to paraphrase the pictorial imagery that had its origin in fifteenth- and sixteenth-century Flanders. Of course, neither the conformation of paint, nor the fusion of brushwork of those paintings was achieved, but the general feeling of fantasy that permeates the work of the early masters was in some measure evoked through using certain compositional devices, as well as observing *chiaroscuro* (marked differentiation between light and dark areas).

 Fantastic Landscape was painted in the following manner. First, an acrylic glaze of yellow oxide was spread all over the 14" x 18" panel. This glaze remained active only in the sky area, where it imparted luminosity to the superimposed glaze of phthalo green and blue mixed with some yellow oxide. The rest of the picture is totally opaque; it received many overpaints, each of which covered the underlying passage completely. Some scumbling was done by dragging a No. 6 bristle brush holding just a little paint. Besides this brush, one small round sable brush and two scriptliners of different sizes were used. Because these were continuously washed in water, these few brushes proved to be perfectly sufficient to handle nine different colors. In addition to white (our gesso), these colors were made up from phthalo blue and green, ultramarine blue, chromium oxide green, yellow oxide, cadmium yellow, raw sienna, raw umber, and black.

Treetrunks

Let us now examine the single motifs found in landscape, such as trees, foliage, and rocks. The photographs of treetrunks on pp. 48, 50, and 78 depict characteristic textures. The one seen on p. 48, because of its variegated texture, served us as a model for *Driftwood* (see demonstration on pp. 48 and 49). Because of the rich configuration of its surface, the underpainting for *Driftwood* was made up of several layers of impasti applied with a bristle brush (which was also used for broad final effects). On top of the impasti, textural variations were indicated by means of "calligraphy" (that is, linear effects) produced with a round sable brush. These calligraphic definitions were made with light paint on the dark surfaces; conversely,

dark paint was used on the light surfaces. The paint was always sufficiently diluted with water, to allow fluent, unimpeded application. In addition to white (gesso), raw sienna, burnt umber, and ultramarine blue acrylic colors were used.

Bark

In the demonstration of *Bark* on p. 50 (see photograph p. 50), a juxtaposition of a very smooth birch bark and one possessing excessive roughness is seen. The smooth birch bark (left) received an almost black, smooth underpainting on which the design of the bark was done with white gesso on a surface moistened with water. Before it dried, a soft paper (newsprint) and a piece of rag were pressed into the surface, thus creating the characteristic blur. Moreover, by scraping into the wet acrylic paint with a palette knife, the dark underpainting revealed itself in dots and fine lines. This manipulation, producing a mottled effect, could also be used for painting skies, rocks, water, etc. Sometimes cheesecloth may serve as a "blotter" to create a certain texture, as well.

The extra-rough bark (right) was achieved by several impasto underpaintings using black and brown acrylic paint. The light effects (the same colors mixed with white) were applied with the blade of a painting knife, which touched only the high impasto.

The photograph on p. 78 served as a guide in painting *Treetrunk* (see demonstration on pp. 78-81). The treetrunk is set against a blue sky, so the underpainting was phthalo blue acrylic color and white (gesso). Because of the extraordinary hiding capacity of acrylic paint, there was no difficulty in painting the motif directly on it.

Foliage

When painting foliage, how can we best organize its multiple effects? This can best be done by glazing the entire area of the foliage as if it were in shade first, and the prominent branches that receive the impact of full light last.

The underpainting of *Treetrunk* was carried out in the following manner. First, the blue area of the sky was spread all over the surface. Next, the treetrunk received a middle tone mixed from umber, black, and white (gesso). The foliage was treated as a mass of dark green color (phthalo blue and cadmium yellow). In the final painting, the shadow part of the trunk was deepened with a glaze of phthalo blue and umber, and all the other parts seen in full light received scumbles — light green in the foliage and a yellowish color in the trunk. The brushes used were a scriptliner, a striper, and a flat and a round bristle brush.

Rocks

The photograph on p. 68 is of a small (7") piece of rock. In painting such subjects — even mountain panoramas (see demonstration of *Mountain Range* on pp. 68-70)

— such miniature samples can serve the painter well. It is a good idea to collect specimens of rocks of various kinds to use as models whenever the occasion arises. Two color schemes went into the underpainting of *Mountain Range,* a bluish gray (umber, phthalo blue, and white gesso) for the mountain area and a brownish tone for the ground. In the second stage of *Mountain Range,* the left side of the painting was not finished in order to give the student a clear view of the progress of the painting. The colors used for the rocks in light were raw sienna and white. These were painted into a wet scumble of phthalo blue, raw sienna, and white. The parts in shade received a mixture of phthalo blue, umber, and white. Phthalo blue, cadmium yellow, umber, raw sienna, and white went into the painting of the foreground. Again the white used was acrylic gesso. The configurations of the rocks were painted with small round sable brushes, which are much better than the scriptliner for making such precise, short strokes.

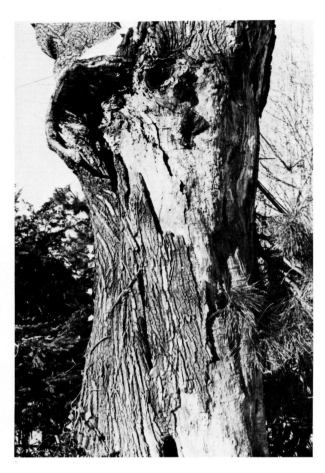

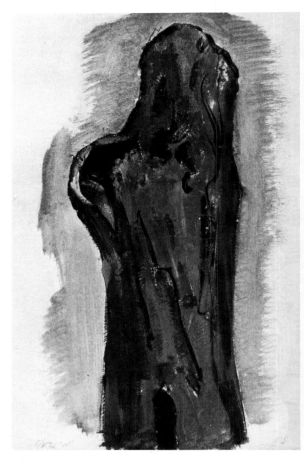

Because of its variegated texture, the treetrunk shown in this photograph served as a model for *Driftwood*.

Driftwood (Underpainting). This underpainting was made up of several layers of acrylic impasti applied with a bristle brush to capture the rich configurations of the surface texture.

(Right) **Driftwood** (Final Painting). Textural variations were indicated on top of the impasti of the underpainting by means of "calligraphy" (that is, linear effects) produced with a round sable brush. These calligraphic definitions were made with light paint on the dark surfaces and with dark paint on the light surfaces. The paint was well diluted with water. In addition to white (gesso), raw sienna, burnt umber, and ultramarine blue acrylic colors were used. Done on 18" × 12" illustration board.

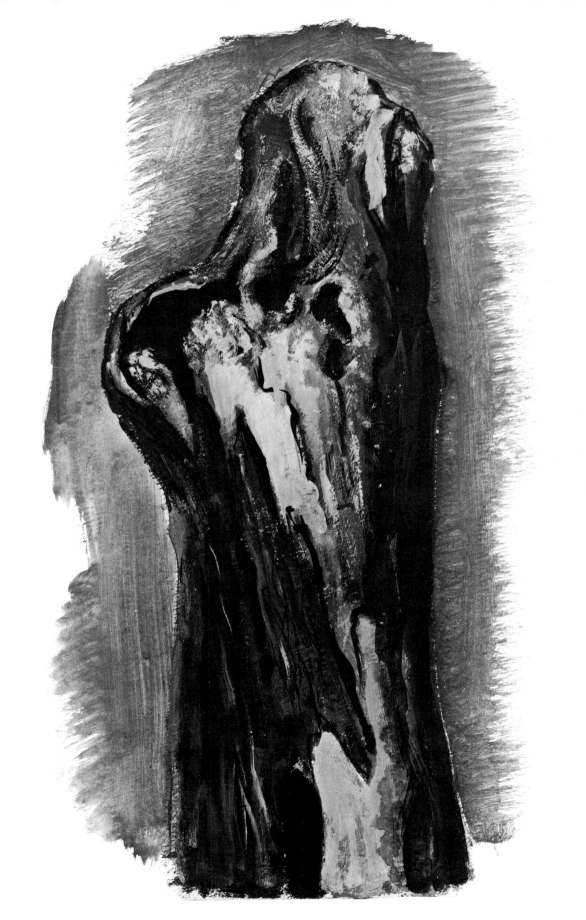

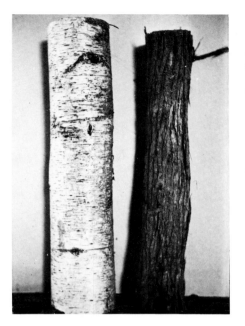

(Left) In this photograph we see the two different kinds of bark, a smooth birch bark (left) and a rough bark (right) which were used as a basis for the study of bark which follows.

(Below) **Bark.** An almost black surface was established on illustration board for the smooth birch bark (left). When the surface was dry, it was moistened with water. White gesso was brushed onto the surface and immediately textured with soft paper and a piece of rag. Next, I scratched into the still-wet gesso with a palette knife to produce the fine marks that characterize this kind of bark. For the rough bark (right), I put down an underpainting of heavy, dark impasto (produced by moving a bristle brush in a vertical direction). In the final painting, lighter scumbles were made by letting the blade of a palette knife come in contact only with the ridges of the impasti brushstrokes.

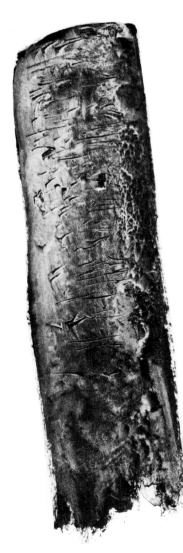

9/PORTRAIT AND FIGURE PAINTING

Again, I must stress the difference between handling acrylic and oil paint. The use of the time-honored, classic *grisaille* (underpainting in grays or monotones), for example, is useless — except when overpainting with oil color is contemplated (see Chapters 11 and 14). Also, painting on a Masonite panel offers no advantage, since blending colors in the usual manner is difficult, unless we resort to the painstaking and unrewarding procedure of constant retouchings or crosshatchings as practiced by the painters of the early tempera school. We must use a surface that allows us to produce so-called "drybrush" effects; that is, a surface suitable for dragging the brush (holding only a little paint) over the top grain of the surface and leaving the declivities free of paint. We find such a surface in illustration board, or a properly prepared canvas (that is, one that has neither too much nor too little tooth).

Preliminary Drawing

When working with acrylics throughout, underpainting a portrait in the traditional manner would not serve a useful purpose. When doing traditional portraiture, we shall have to carry out a finished (that is, accurate) drawing in pencil or charcoal of the sitter first. This should be done on paper, then transferred by means of graphite transfer paper to the canvas or board. Upon receiving necessary correction, the drawing should then be made indelible with fixative. Of course, those skilled in portraiture may be able to sketch directly onto the support — even with paints — but I am addressing the student, not the virtuoso. Hence my advice: attend to the drawing first!

Head Study

The *Head Study* (see demonstration on pp. 82 and 83) was painted on a small 12" x 9" panel. I applied a thin color of burnt sienna in the area of the face and the same color mixed with phthalo green over the rest of the surface. I then sketched the face in with charcoal before painting it.

The four acrylic colors used for painting the complexion in *Head Study,* besides white (this time, the white was not gesso; a tube color was used, since I needed a paint of heavier body), were yellow oxide, red oxide, burnt umber, and phthalo blue. This combination of colors is useful because they can be intermixed more easily than any others, making it possible to produce every conceivable skin color, including all shades of brown and black skin.

For the parts in shade, I mixed all four colors, more or less of this or of that,

depending on the desired tonal value and density of the shade; or sometimes I omitted one or the other, to radically change the tonality. For the lights, I used yellow oxide and white in addition to some umber (the yellow umber affects how high or low the key of the color in the light parts will appear).

Following the precepts of *alla prima* painting (as far as the acrylic medium allows), the headdress was thinly glazed with burnt umber. Then it received a scumble of cadmium red in the areas of the light; the background was covered with a scumble of phthalo green and white. The sparse overpainting allowed the sketchiness of the work to be preserved by revealing some of the underlying color.

I used two No. 6 bristle brushes, one for the light parts of the face, another for the shadow. The same brushes were also employed for painting the headdress and the background. The features were defined with a small round sable brush.

Figure Study

The *Figure Study* opposite was done on illustration board, which was medium rough in texture. It received two primings of gesso applied with a spatula. The ground was given a "middle tone" (neither too dark nor too light) mixed from burnt umber and white (gesso), and the acrylic colors were the same used for painting flesh in portraiture — yellow oxide, red oxide, umber, and ultramarine blue. The size of the picture allowed the use of a round bristle brush and, since loose brushstrokes appeared to be desirable, only a scriptliner and a striper were used in addition to this. The painting is opaque throughout.

Figure Study. This study was done entirely in opaque acrylic colors on medium rough, 18" × 12" illustration board. It received two primings of acrylic gesso, applied with a spatula. The ground was given a middle tone (neither too dark nor too light) mixed from burnt umber and white (gesso). The colors were the same as those used for painting flesh in portraiture—yellow oxide, red oxide, umber, and ultramarine blue. I used a round bristle brush to obtain loose brushstrokes, as well as a scriptliner and a striper.

10/MURAL PAINTING

Acrylic paints can be used directly on any conceivable support: unpolished metal, glass, stone, cement, plaster walls, etc. Although water-insoluble, the paint is not water-impenetrable. Thus, it is not suited to outdoor exposure. Should water enter through the minute pores of the paint film, the paint could be stripped from the surface, especially in the case of paints with a smooth, nonabsorbent finish. When painting murals, the best surface is, of course, a plaster wall (not necessarily white) which is free from previous applications of paint, especially oil paint. A surface covered by a heavy film of oil color should be sanded. If desired, it can then be gessoed. If too absorbent, acrylic medium can be used for sizing the wall.

Brushes

Round bristle brushes are particularly practical for mural painting. Such brushes, because of their great mobility, are excellent for the execution of large designs. Flat bristle brushes (No. 12 and larger) are very efficient in treating large flat surfaces such as backgrounds. Needless to say, soft hair brushes cannot be used for mural painting; they would wear out too rapidly.

The traditional Italian term used for painting on wet plaster is *fresco buono,* a technique common in all classic mural painting employing pigment dispersed in lime water. *Fresco secco* (painting on dry plaster) was used only as a supplementary technique, because it lacked sufficient permanence and was not on the same level esthetically.

Preparation

Acrylic paint cannot be used on wet plaster, but it is, more than any other material, suitable for mural painting. Because the paint used in murals should not be of firm consistency, the acrylic sold in jars is preferable to the tube paint. However, when engaged in working on large surfaces, you may prefer to prepare the paint yourself by mixing dry pigments with acrylic medium, preferably matte medium. A spatula is all we require for this task. The pigments are rubbed vigorously into the medium to form a dense, liquid consistency. The paste should be thinned with water (or water mixed with acrylic medium) until a free-flowing consistency is obtained. For white, we use acrylic gesso, which can also be thinned with water.

Premix Your Colors

When painting large surfaces, we cannot very well mix every daub of color as we go along, as we do when painting on a canvas placed on an easel. In mural painting, we shall have to premix batches of colors and place them in dishes of appropriate size (according to the extent of our work and the length of time we plan to devote to the task).

For example, when painting flesh, we shall need four containers for the following: the color of the light parts (yellow oxide and white), the color for the middle tone (yellow oxide, red oxide, umber, and white), and the color for the deepest shadows (same as former, but mixed with much less white). In addition, we shall require (besides white) all the other colors called for by a specific work. These should be also premixed (in consistency to be readily used) and placed in containers of appropriate size.

Light and Shade

The two examples of mural painting shown on pp. 97 and 99 are based on Michelangelo's designs from the Sistine Chapel. In the first (p. 97), an attempt was made to follow the original in its treatment of light and shade, as well as in technique (that is, as much as the *secco* method can be made to resemble the true fresco executed on wet plaster).

Line

In the second example (p. 99), emphasis is put on the flatness of the surface and the presentation of the design by linear means. Here, unlike in the first study, the painting was not done on a white surface; for this particular technique, it appeared more appropriate to color the gesso in some manner. Hence, I applied a gray produced from umber, ultramarine blue, and white gesso on top of the white surface. This was then covered with a glaze of burnt umber. Upon this warm, medium gray tone, all the colors that were mixed with white registered their presence at once, vigorously.

Color Chart. The acrylic color mixtures on the left of each box are pure; white (acrylic gesso) has been added to those on the right.

Phthalo blue and Yellow oxide	Phthalo blue and Cadmium yellow	Phthalo blue and Cadmium red
Phthalo blue and Acra violet	Phthalo blue and Chromium oxide green	Ultramarine blue and Yellow oxide
Ultramarine blue and Cadmium yellow	Ultramarine blue and Burnt sienna	Phthalo green and White
Phthalo green and Cadmium yellow	Phthalo green and Yellow oxide	Chromium oxide green and Cadmium yellow
Yellow oxide and Red oxide	Yellow oxide and Burnt sienna	Yellow oxide and Burnt umber
Cadmium yellow and Cadmium red	Cadmium yellow and Burnt umber	Cadmium yellow and Mars black
Acra violet and Ultramarine blue	Acra violet and Cadmium red	Burnt umber, Phthalo blue, and white

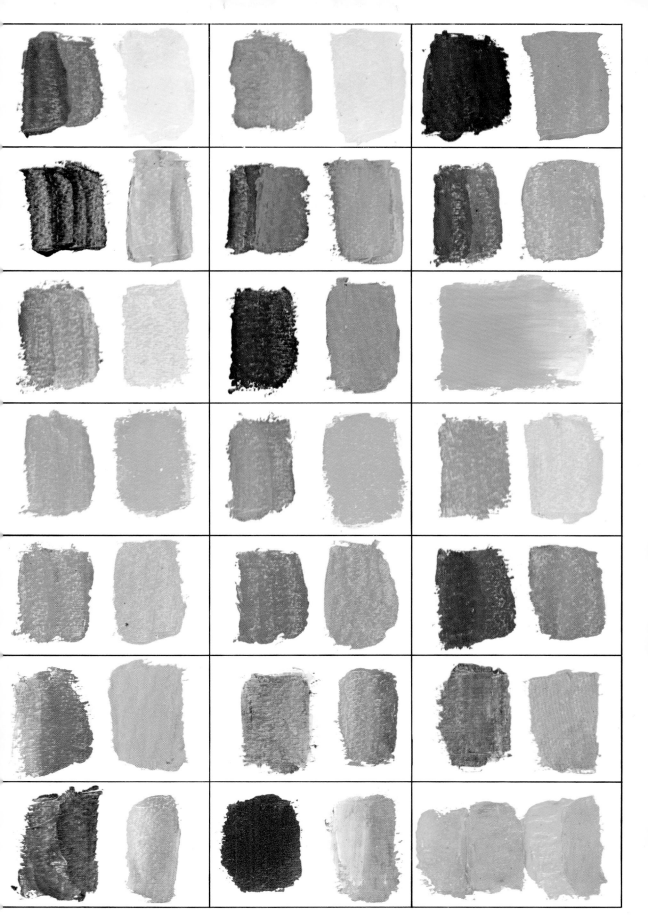

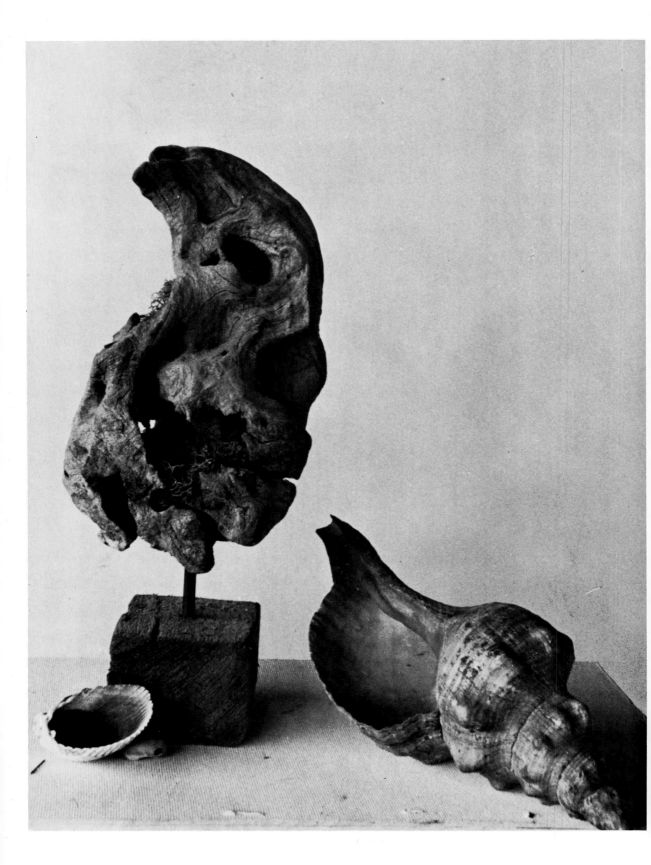

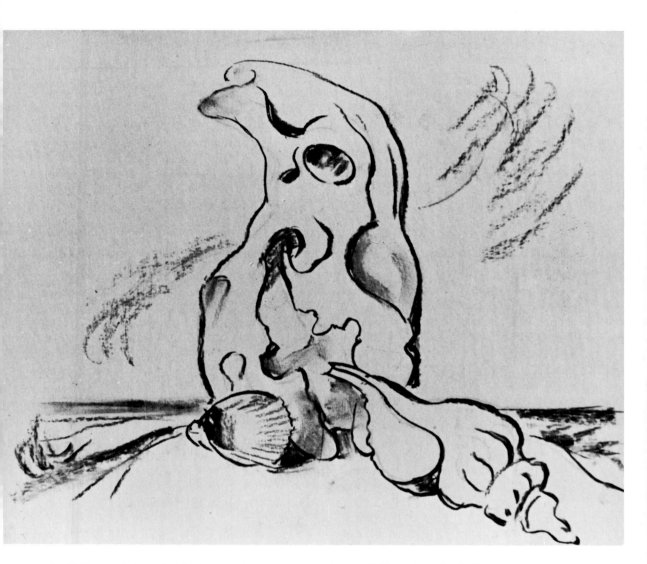

(Left) The motif shown in this photograph was the basis of *Driftwood and Shells*.

(Above) **Driftwood and Shells.** (Preliminary Sketch) Interest was centered on composition, and on a realistic rendering of the objects.

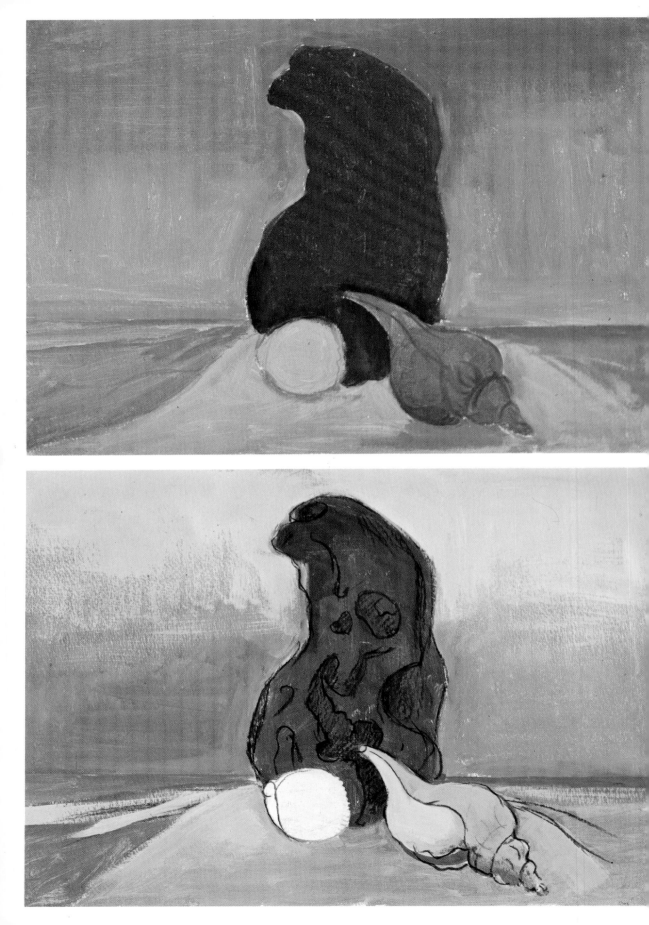

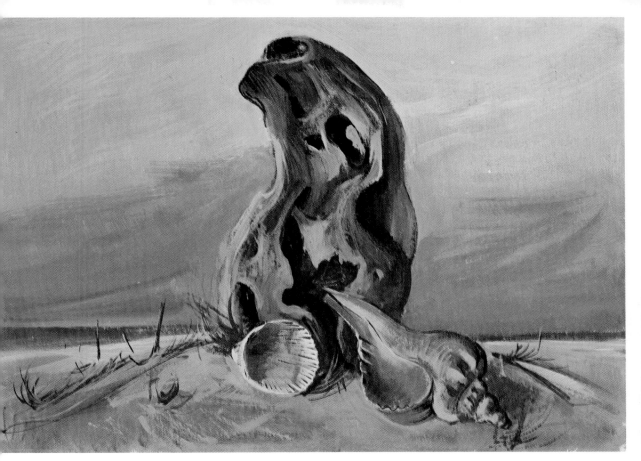

(Above Left) **Driftwood and Shells** (First Underpainting). Despite three primings, the illustration board ground retained a slightly pebbly surface. Because of this character of the surface, the ground was primed with a spatula. The following acrylic colors were used (the white was acrylic gesso): pink (red oxide and white) for the sky; umber, raw sienna, and white for the ground; raw and burnt umber for the driftwood; raw sienna and white for the small shell; and raw sienna, umber, and white for the large shell. A bristle brush was used to rub the paint thinly into the surface. To add interest to the design, the objects were conditioned by endowing them with a certain asymmetry. The colors were employed freely in the "open color" technique; they do not coincide with the shapes of the objects. The lines of the drawing were reinforced with cadmium red, using a scriptliner.

(Below Left) **Driftwood and Shells** (Second Underpainting). The upper part of the sky was lightened by a scumble of yellow oxide and white. The large shell was overpainted with cadmium yellow and white, and the small shell with white. Again, the white used was acrylic gesso. The drawing of the objects was developed with charcoal, than fixed with fixative. The most conspicuous characteristic of this underpainting is its absence of color blending. Such an absence

would be totally inappropriate when working in oil colors, which, compared to acrylics, do not possess equal hiding power. Even the casualness of the lines is unobjectionable, because any needed modifications can easily be carried out on top of them.

(Above) **Driftwood and Shells** (Final Painting). Several impasto underpaintings preceded the final painting. The surface details were made with a scriptliner and a striper, using light and dark linear definitions. I also used a round sable and a No. 7 round bristle brush. The only glazes appear in the shadow area, where the color was diluted to watercolor consistency. The effects of glazing and scumbling were achieved by means of dry-brush technique (darker colors dragged with a lightly charged bristle brush over lighter colors) and, conversely, by applying lighter colors sparingly over darker ones. I used these acrylic colors for the final painting (the white used was acrylic gesso): phthalo blue, burnt sienna, and white for the sky (opaque in the lower part, very thin at the top, with a yellow oxide and white scumble brushed over it); raw and burnt umber, raw sienna, black, and white for the driftwood; yellow oxide, raw sienna, raw umber, and white for the ground; acra violet and black for the small shell; and burnt umber, cadmium yellow, and white for the large. Done on 13" x 17" board.

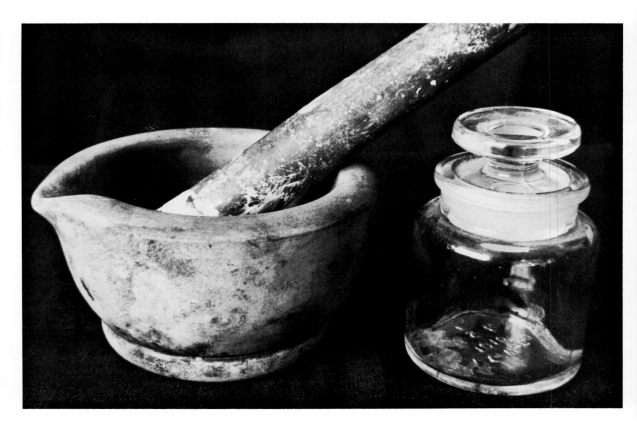

(Above) This photograph shows two of the main objects used in the composition of *Painter's Still Life.*

(Above Right) **Painter's Still Life** (Preliminary Sketch). We see the mortar and pestle and the glass jar shown in the photograph incorporated into a realistically rendered composition of artists' materials.

(Below Right) **Painter's Still Life** (Underpainting). Here, as in the previous example of the still life with bottles, the "open color" technique was used. But in this case, the objects were not distorted or made flat; they were rendered with great emphasis on three-dimensional quality.

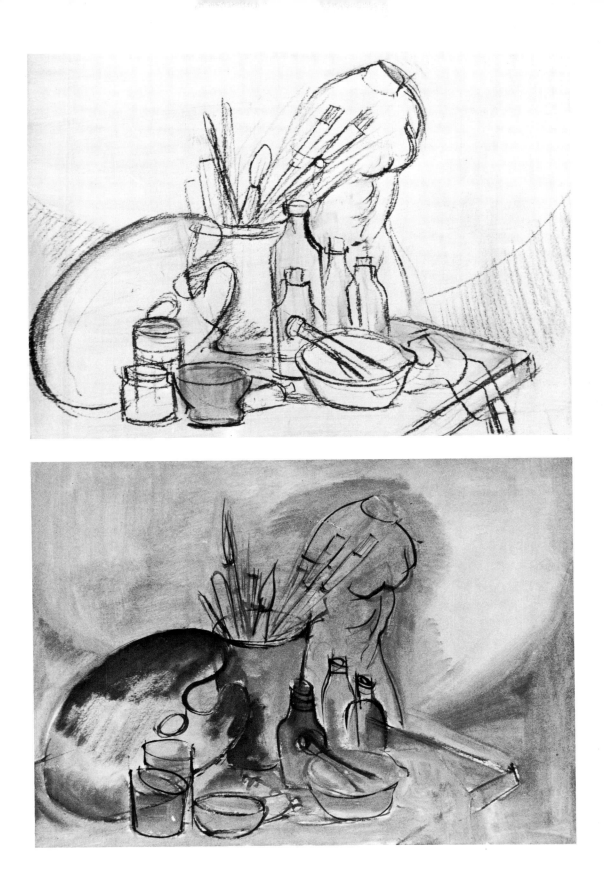

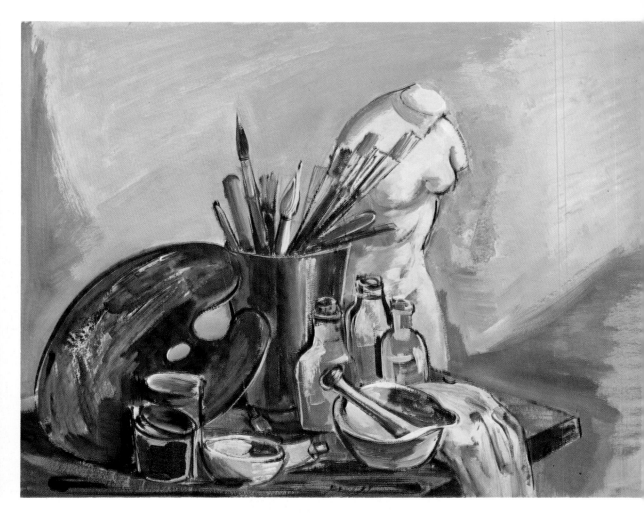

Painter's Still Life (Final Painting). The final painting was done predominantly in opaque acrylic colors (with some glazes in the background). The rather sober elements in the composition were done sketchily, stressing the arabesque quality of the outlines, with a scriptliner and a striper — the only brushes capable of producing this kind of free-swinging calligraphy. I also used round and flat bristle brushes. Done on 18'' x 25'' illustration board.

(Above) This photograph of an oak board offers a detail of wood grain.

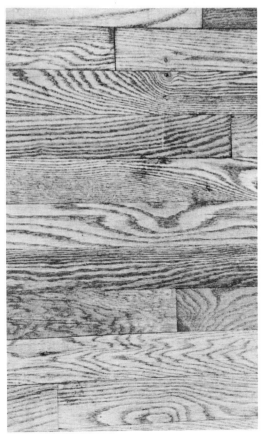

(Left) This photograph of pine boards illustrates the variegated pattern of wood grain.

Wood Grain (Mixed Technique)

A: The illustration board surface was covered with acrylic yellow oxide mixed with white acrylic gesso.

B: This surface was then glazed with burnt umber oil color.

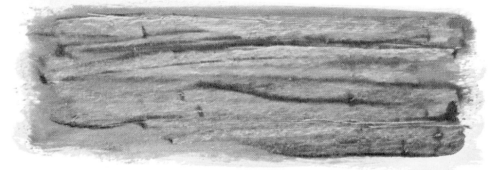

C: The light underpainting was relieved by scraping into the glaze with a palette knife.

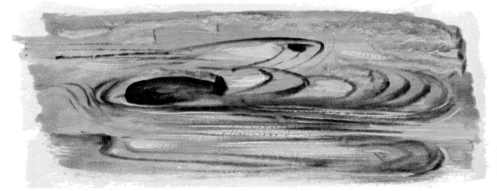

D: A dark graining was produced with a scriptliner and umber oil color; the lightest accents were done in ochre and white oil colors. The whole process was carried out wet-in-wet.

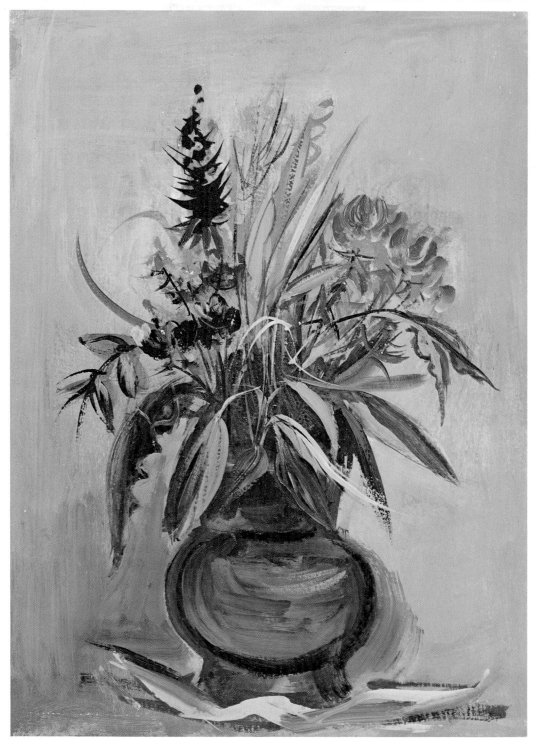

Field Flowers. This flower still life was painted with acrylic colors on a 12″ x 9″ panel, which was first gessoed. The area of the bouquet and the vase was stained with yellow (cadmium yellow and white); the background with phthalo blue and white. The following colors were used over this stain (in addition to white, which was acrylic gesso): phthalo blue, cadmium yellow, cadmium orange, cadmium red, raw and burnt sienna, and acra violet. The medium, as usual, was 1/2 water, 1/2 acrylic medium. The brushes were all sables — round, flat, and a scriptliner. The scriptliner was used exclusively for long, fine definitions. In the area around the floral motif, where the original background color is seen, the rendition was opaque. Scumbling can be seen in a few instances.

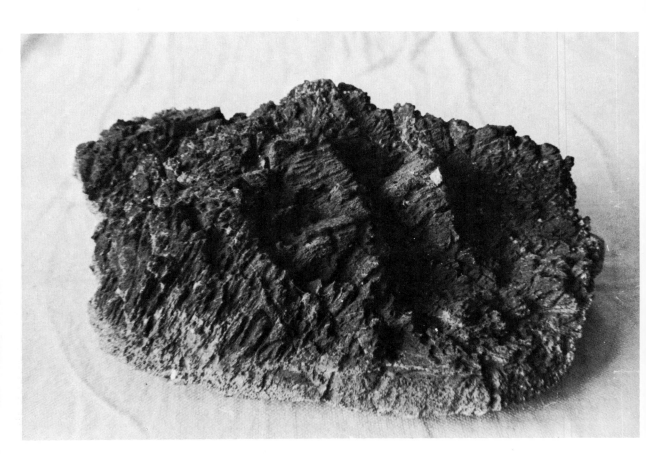

This is a photograph of a small (7") piece of rock, used as a miniature model for painting *Mountain Range*.

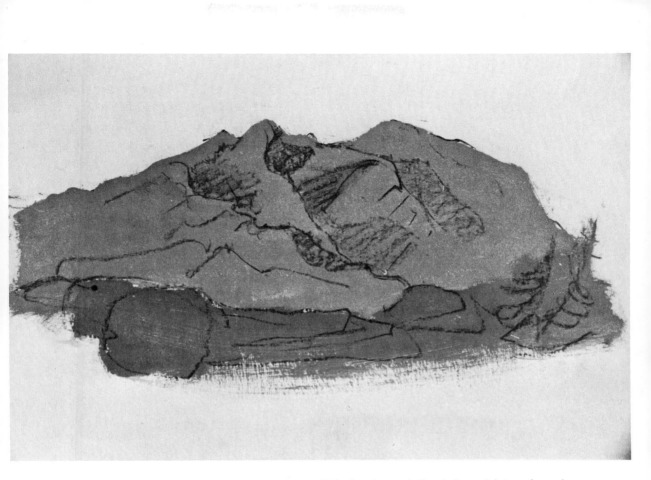

Mountain Range (Underpainting). Here, the small bit of rock seen in the photograph is transformed into a mountain range. A bluish gray (umber, phthalo blue, and white gesso) was used for the mountain area, and a brownish tone (umber, raw sienna, and white gesso) was used for the foreground. The drawing on top of the acrylic underpainting was made with charcoal and fixed with fixative.

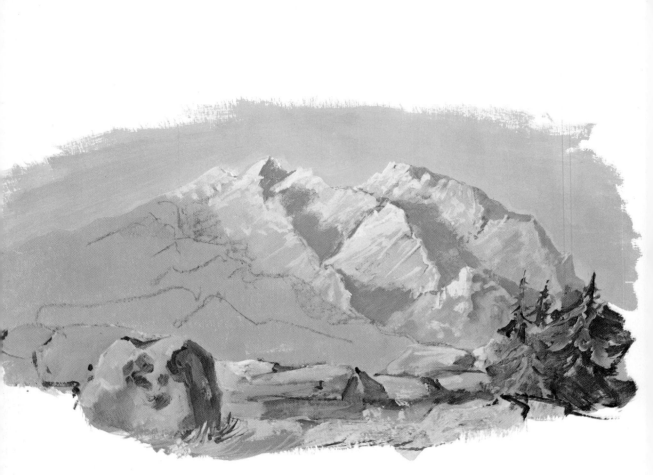

(Above) **Mountain Range** (Second Stage). For the sake of demonstration, only the right side of the painting was finished. The acrylic colors used for the rocks in light were white (gesso) and raw sienna. These were painted into a wet scumble of phthalo blue, raw sienna, and white (gesso) acrylic colors. The parts in shade were painted with a mixture of phthalo blue, umber, and white (gesso) acrylic colors. The foreground was painted with phthalo blue, cadmium yellow, umber, raw sienna, and white (gesso) acrylic colors. The configurations of the rocks were painted with small sable brushes. Done on 12" x 18" illustration board.

(Right) **Flower Bouquet** (Mixed Technique). This painting was done on a 13" x 9" panel on an acrylic ground (imprimatura) of pale blue in the area of the background and yellow (cadmium yellow and white gesso) in the center. I used a painting knife and a contingent of sable brushes. This is the same flower study — done in the mixed technique — as the one executed in pure acrylic colors entitled *Field Flowers* on page 67. In this instance, the final painting in oil colors was preceded by applications of films of brilliant oil colors (cadmium yellow dark, cadmium orange, and red) spread with a knife very thinly over the acrylic yellow ground. The following oil colors were used for the final painting: ultramarine blue, Prussian blue, viridian green, Naples yellow, ochre, cadmium yellow light, medium orange and red, burnt sienna, alizarin crimson, and Mars violet.

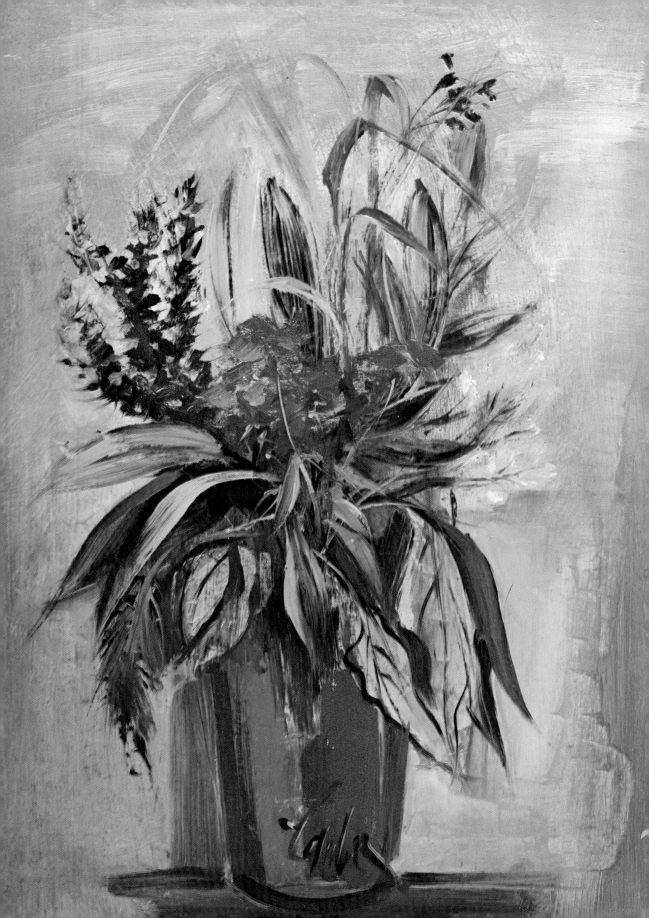

Glazing. These examples of acrylic glazing were carried out over grounds of three different acrylic colors, as well as over an impasto ground. The white used was acrylic gesso.

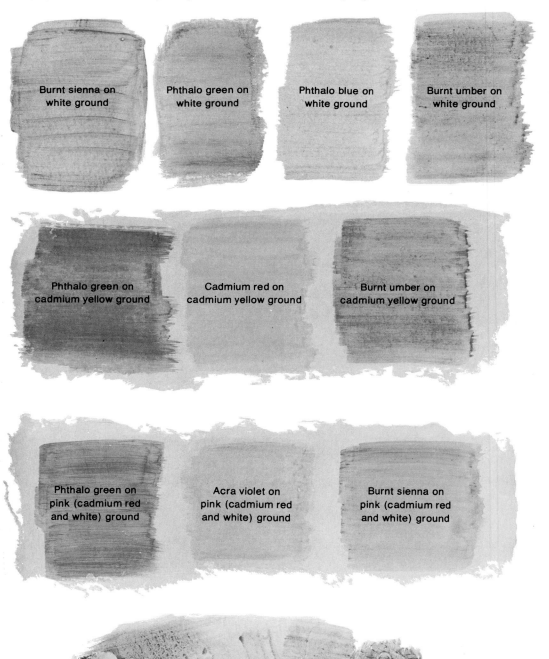

Burnt sienna on white ground

Phthalo green on white ground

Phthalo blue on white ground

Burnt umber on white ground

Phthalo green on cadmium yellow ground

Cadmium red on cadmium yellow ground

Burnt umber on cadmium yellow ground

Phthalo green on pink (cadmium red and white) ground

Acra violet on pink (cadmium red and white) ground

Burnt sienna on pink (cadmium red and white) ground

White impasto glazed with burnt sienna and phthalo green

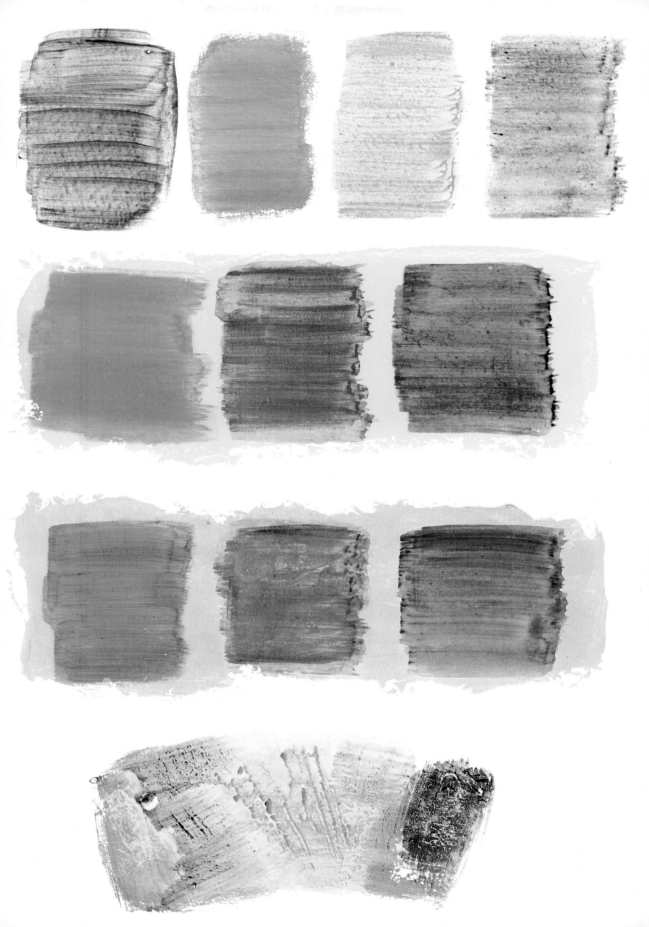

(Above) A pineapple set up for the mixed technique study which follows.

(Right) **Pineapple** (Underpainting). The initial sketch for this pineapple was done with a scriptliner on an acrylic underpainting of raw sienna.

Pineapple (Final Painting, Mixed Technique). The raw sienna acrylic underpainting was glazed with a mixture of viridian green and burnt sienna oil colors. Then the surface texture was added, and its deepest accents painted, using the same oil colors. All the lighter definitions were painted, using ochre, white, and a dash of burnt sienna oil colors. For the leaves, I used Prussian blue, cadmium yellow, and white oil colors. The pineapple was painted with bristle brushes; the background was painted with a palette knife. Done on illustration board.

(Above) **Deciduous Tree** (Mixed Technique). A cadmium yellow and white (gesso) acrylic underpainting was thinly glazed with burnt sienna and Prussian blue oil colors in the mixed technique on illustration board. Configurations of foliage and the design of the branches were then painted (with the same oil colors, but of greater density) into the wet glaze with a round sable brush. Last, all areas in light were painted into the wet glaze, using cadmium yellow and white oil colors.

(Below) **Evergreen Tree** (Mixed Technique). As in the deciduous tree in the preceding example, an acrylic underpainting of cadmium yellow and white (gesso) was glazed with a thin mixture of burnt sienna and Prussian blue oil colors in the mixed technique on illustration board. The foliage was painted into the wet glaze with a scriptliner. The same brush was used for the lights, which were painted with a mixture of cadmium yellow and white oil colors.

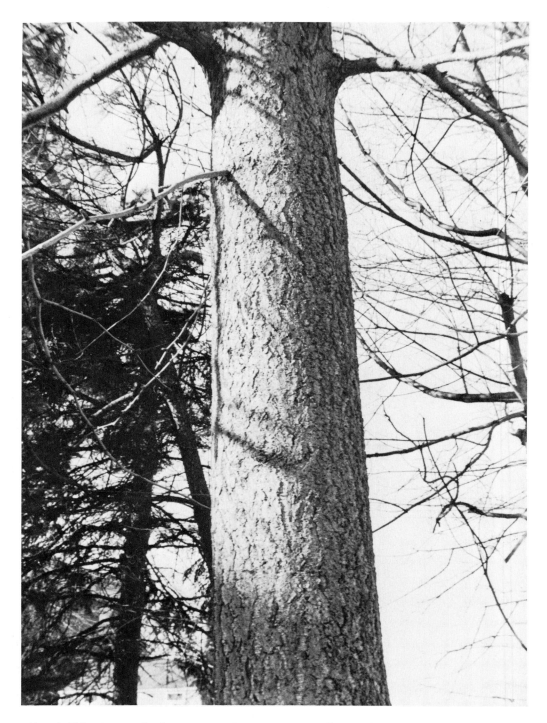

(Above). This photograph of a tree served as a guide in painting *Treetrunk*.

(Right) **Treetrunk** (Underpainting). Because this tree is set against a blue sky, the acrylic underpainting was a blue color (phthalo blue and white gesso), which covered the entire support. And because of the extraordinary hiding capacity of acrylic paint, there was no difficulty in painting the motif directly on top of the blue underpainting.

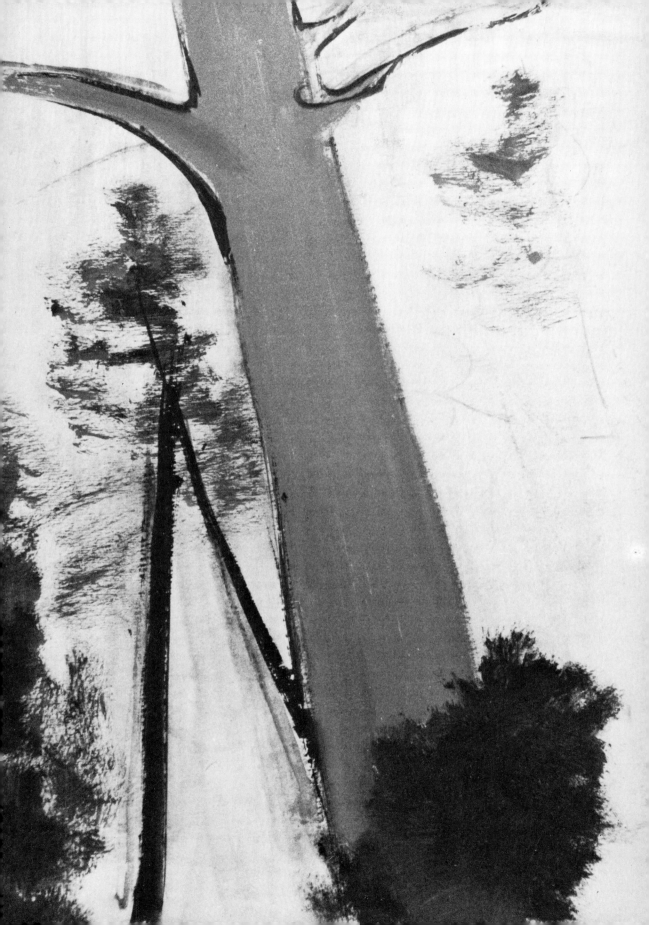

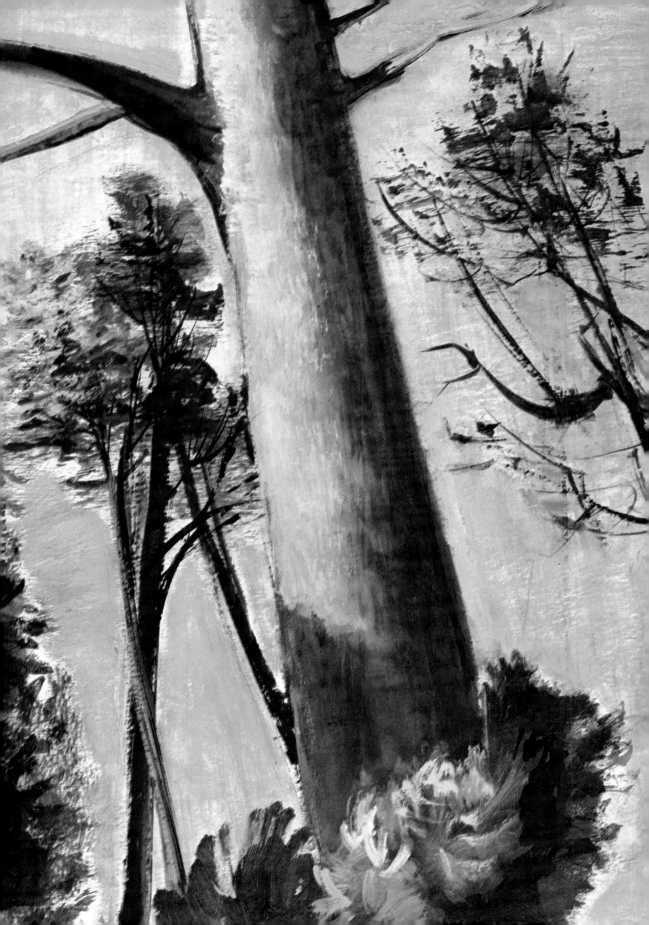

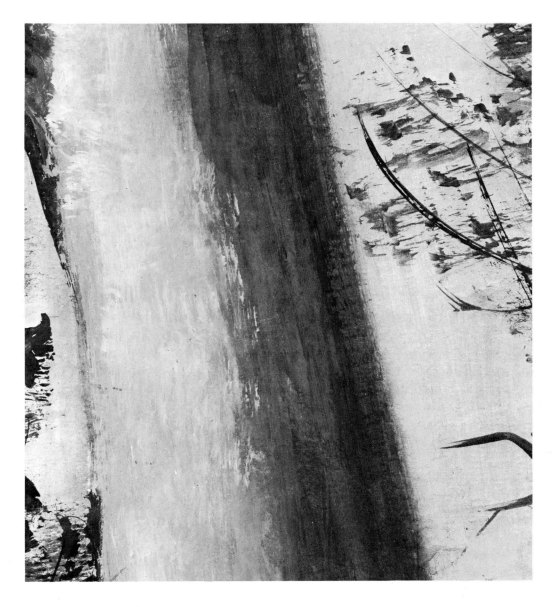

(Left) **Treetrunk** (Final Painting). This treetrunk received an acrylic color approximating its middle tone (that is, a tone mediating between the lights and the shadows), which was a grayish brown (umber, black, and white). The foliage was underpainted in dark green (phthalo blue and cadmium yellow). In the finished painting, the treetrunk was glazed in the shadow part with phthalo blue and umber acrylic colors and in the light part it was scumbled with raw sienna and white. The foliage, seen in full light, was painted with cadmium yellow, phthalo blue, and white acrylic colors. The white used was acrylic gesso. The brushes were a scriptliner, a striper, and a flat and a round bristle brush. Done on 18" x 12" illustration board.

(Above) Detail of *Treetrunk.*

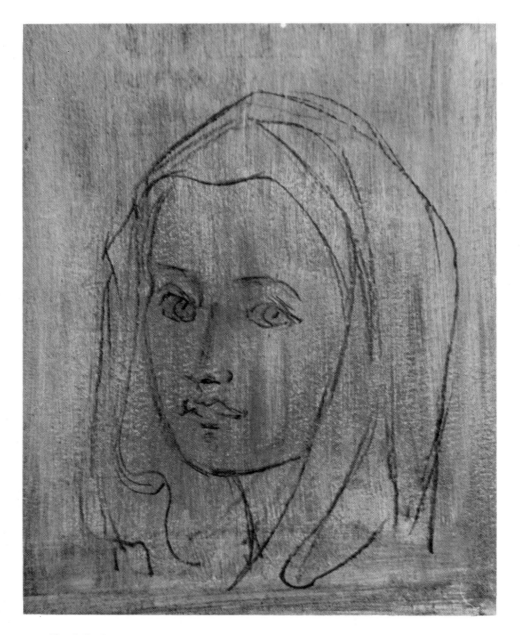

(Above) **Head Study** (Underpainting). For the underpainting of this head study, I applied a thin coat of burnt sienna acrylic color in the area of the face, and the same color mixed with phthalo green acrylic color over the rest of the surface. I then sketched in the face with charcoal.

(Right) **Head Study** (Final Painting). The four colors used for painting the complexion, besides white (this time the white used was not acrylic gesso; a tube color was used, since I needed a paint of heavier body), were yellow oxide, red oxide, burnt umber, and phthalo blue. For the parts in shade, I mixed all the colors; for the lights, I used white and yellow oxide, in addition to some umber. The headdress was thinly glazed with burnt umber; it received a scumble of cadmium red in the areas of light. The background was covered with a scumble of phthalo green and white. The sparse overpainting allowed the sketchiness of the work to be preserved by revealing some of the underlying color. I used two No. 6 bristle brushes, one for the light parts and one for the shadows. The same brushes were also used for painting the headdress and the background. The features were defined with a small round sable brush. Done on small 12" x 9" panel.

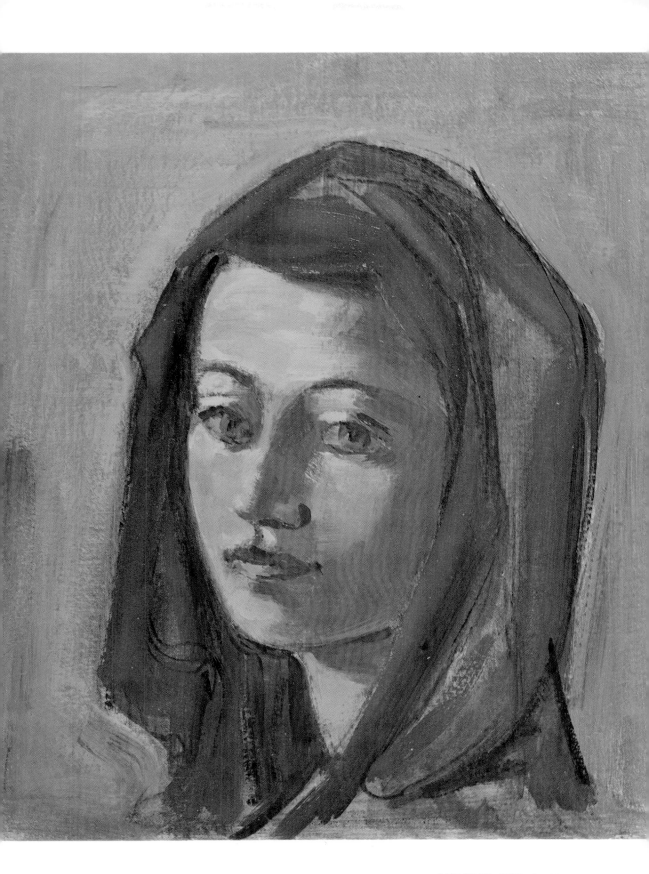

Grapes, set up for the mixed technique study which follows.

Grapes (Underpainting). A dull yellow (yellow oxide and white gesso) was used for the acrylic underpainting. The contour of the grapes was indicated with a scriptliner.

Grapes (Final Painting, Mixed Technique). The entire surface was glazed with viridian green oil color over an acrylic underpainting of dull, pale yellow (yellow oxide and white gesso). This established the middle tone (the color of the grapes was green). For the parts in the shade, viridian green was mixed with ultramarine blue, cadmium yellow, and a touch of burnt sienna oil colors. Next, the contours of the grapes were indicated with a small, round sable brush; their reflections were obtained by wiping some of the glaze off (also with a round sable brush). Then the areas in light were painted with a mixture of viridian green, cadmium yellow, and white oil colors. Finally, the painted surface was blended with a soft hair blender. Done on illustration board.

Figures in Interior (Mixed Technique). This painting was done on a small 9" x 11" panel with interchanging round sable brush and painting knife strokes. Much of its design was done in "open color," used chiefly on the two side sections. These originally carried an acrylic imprimatura of phthalo green; then they were glazed with viridian green oil color. Next, the figures were painted in light flesh colors and outlined with a scriptliner in Mars violet and white oil colors. The middle section received an acrylic imprimatura of burnt sienna, on which the central figure was finished in oil colors in a sketchy manner, relying largely on linear accents.

Scumbling. These examples of scumbling were carried out over three different acrylic under-paintings. The white used was acrylic gesso.

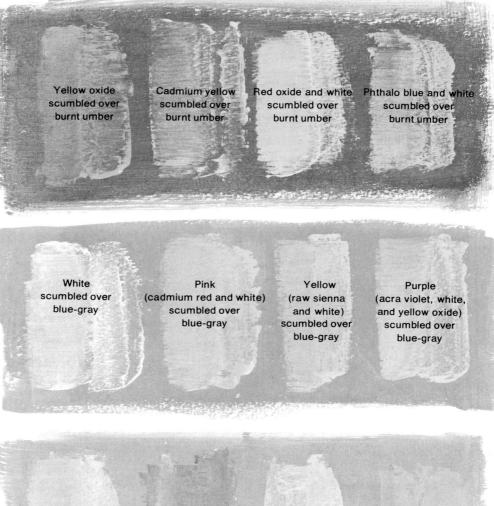

Yellow oxide scumbled over burnt umber

Cadmium yellow scumbled over burnt umber

Red oxide and white scumbled over burnt umber

Phthalo blue and white scumbled over burnt umber

White scumbled over blue-gray

Pink (cadmium red and white) scumbled over blue-gray

Yellow (raw sienna and white) scumbled over blue-gray

Purple (acra violet, white, and yellow oxide) scumbled over blue-gray

Blue (ultramarine blue and white) scumbled over red oxide

Green (phthalo green and cadmium yellow) scumbled over red oxide

Purple (acra violet and white) scumbled over red oxide

Brown (raw umber and white) scumbled over red oxide

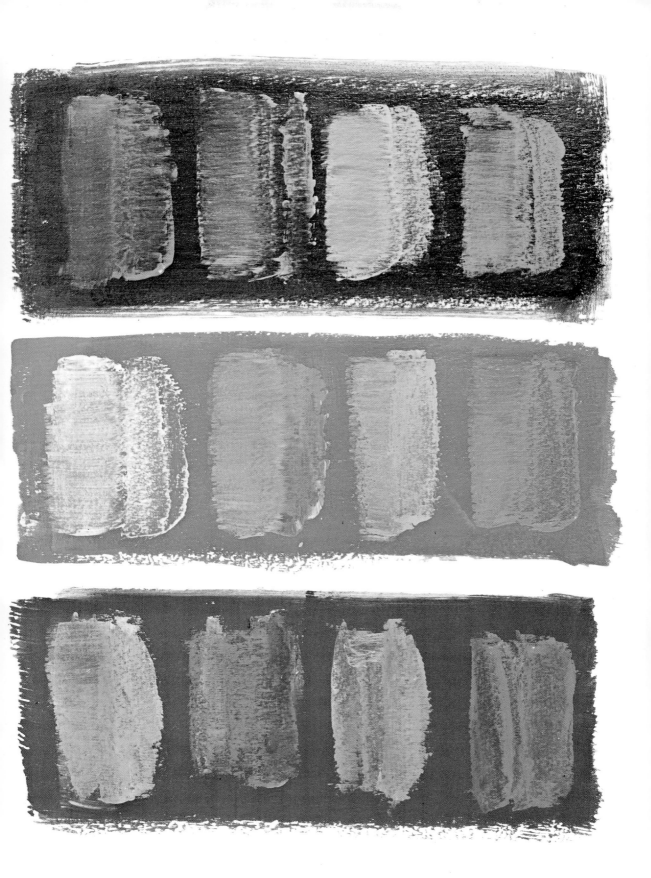

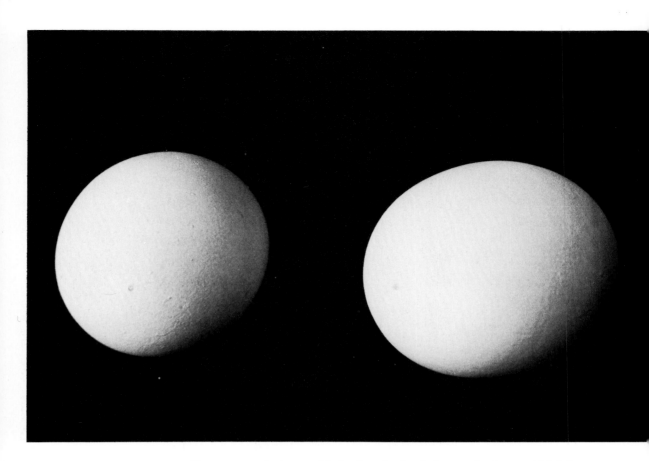

These eggs served as models for the mixed technique study of eggs which follows.

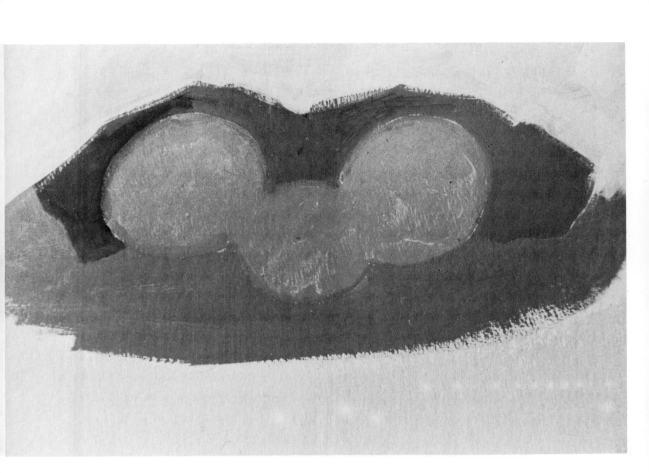

Eggs (Underpainting). The acrylic underpainting for this essentially monochromatic subject served chiefly to make the body of the paint applied on top of it more substantial and to fill in the interstices of the support.

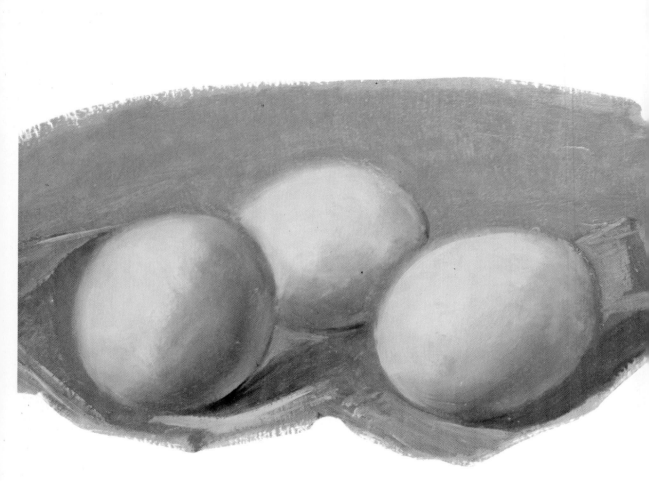

Eggs (Final Painting, Mixed Technique). The delicate blending of light and shade and the outlines of the eggs were accomplished by first brushing the gray (mixed from Prussian blue, umber, and white oil colors) with flat sable brushes — and then with a soft hair blender — over the acrylic underpainting. To produce such perfect blending, the paint should be applied thinly; heavy paint cannot easily be managed in this manner. The paint should also be of a sufficient viscosity. Done on illustration board.

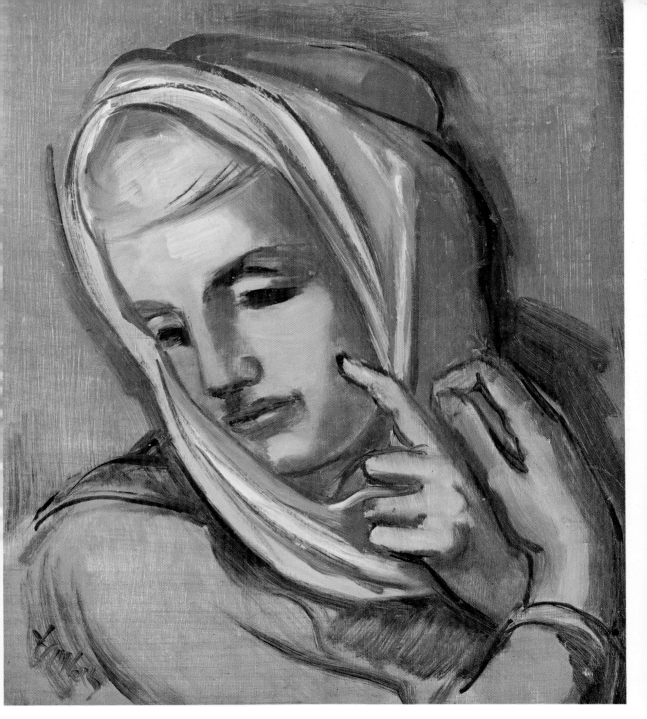

Study after Michelangelo (Mixed Technique). To emphasize the contrast between the different techniques, I have chosen the same subject represented in the *Mural Painting after Michelangelo* on page 97. In this example, a 12" x 10" panel carries an acrylic imprimatura of yellow oxide with some burnt umber added to lower its key. This color is evident in all areas that received oil color glazes, such as the background and the parts of the face and hands in shade. The initial imprimatura remained untouched in its original condition on the garment, marked only by a few thinly applied brushstrokes indicating the folds of the sleeve. Opaque passages are seen on the light parts of the face, the hands, and the turban. The following oil colors were used for the flesh: ochre, Venetian red, burnt umber, ultramarine blue, and white. The background was painted with ultramarine blue, umber and white, the turban with Mars violet, Venetian red, umber, and white.

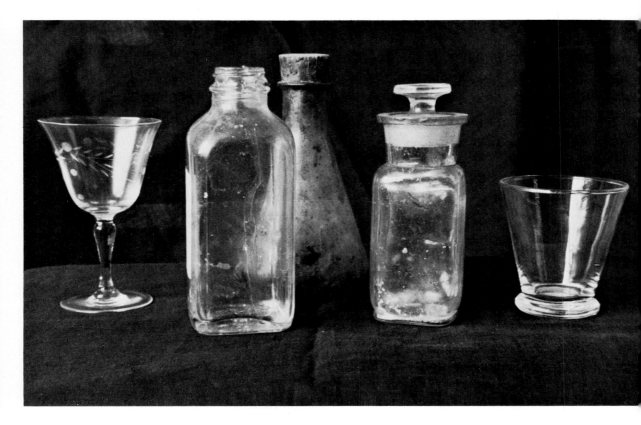

(Above) The arrangement of the glass objects in this photograph was somewhat modified in the composition of *Still Life with Glass Objects*.

(Above Right) **Still Life with Glass Objects** (Preliminary Sketch). The emphasis is on design (that is, on formal arrangement, rather than on realistic representation). The composition aims at the geometric, harmonious interrelationship of masses. When stressing the elements of design, the linear treatment prevails; the three-dimensional aspects of an object are largely depreciated.

(Below Right) **Still Life with Glass Objects** (Underpainting). Transparencies and opacities interchange throughout this composition. Because the colors of the glass objects are monochromatic, the objects were underpainted in a variety of acrylic grays (umber, phthalo green, a little yellow oxide, and white gesso).

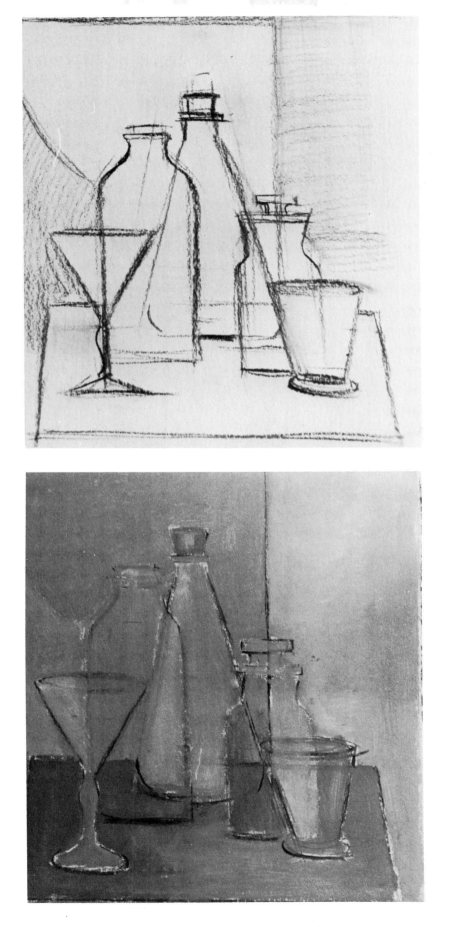

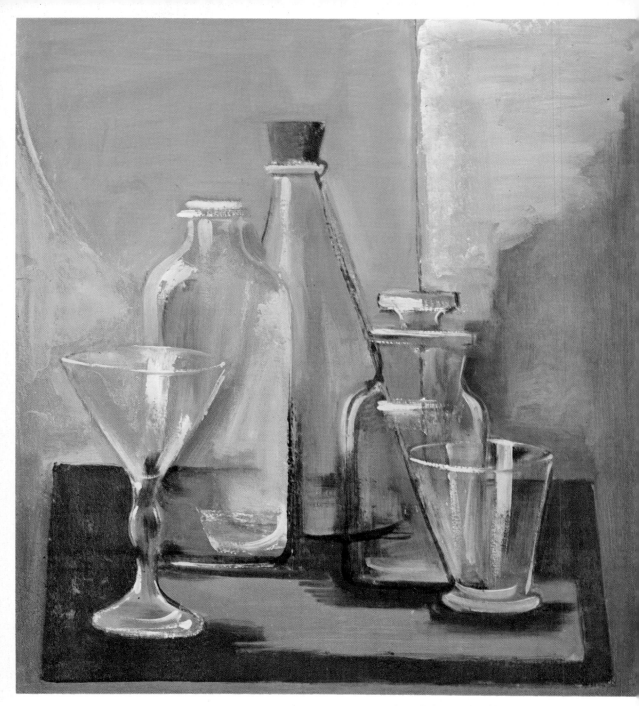

(Above) **Still Life with Glass Objects** (Final Painting, Mixed Technique). The lighter grays of the acrylic underpainting gave me the opportunity for glazing, and the darker grays for scumbling, with opacity applied here and there. The following oil colors were used in the finished painting: umber, burnt sienna, Naples yellow, Prussian blue, and viridian green. A scriptliner and a striper were used for the delineations, a palette knife for the broad definitions. Done on illustration board.

(Right) **Mural Painting after Michelangelo** (Study in Tone). Here, I attempted to follow the original mural painting in the Sistine Chapel in its treatment of light and shade, as well as in technique (that is, as much as the *fresco secco* method can be made to resemble the true *fresco buono* method executed on wet plaster). I used round and flat bristle brushes, in addition to a large round sable brush. Done on 18'' x 12'' illustration board. (See detail on following page.)

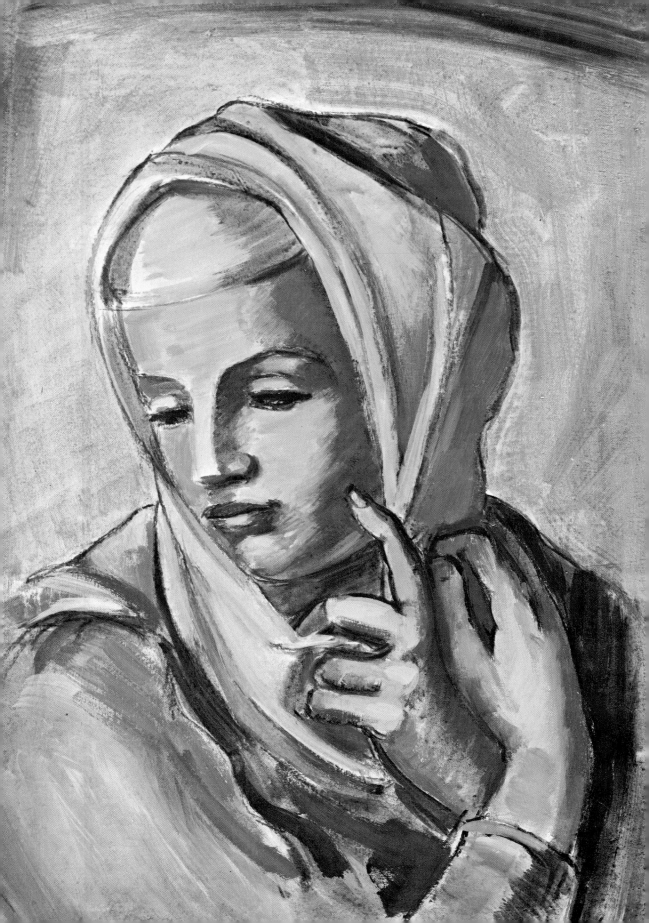

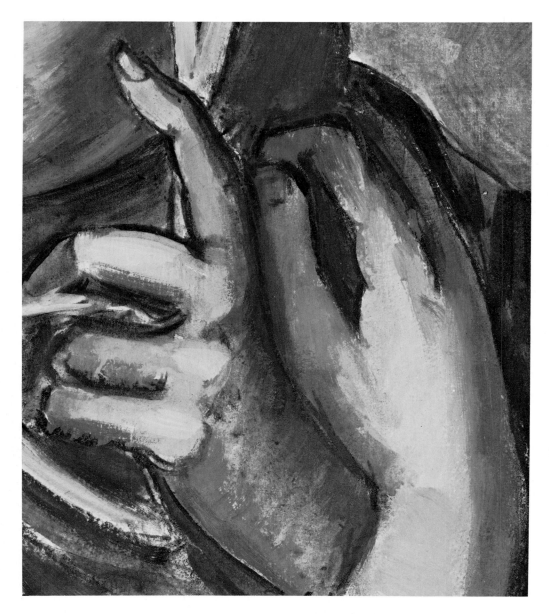

(Above) Detail of *Mural Painting after Michelangelo* (Study in Tone, preceding page)

(Right) **Mural Painting after Michelangelo** (Study in Line). Here, emphasis is put on the flatness of the surface; the design is presented by linear means. For this particular technique, done entirely in acrylic colors on 18" x 12" illustration board, it appeared appropriate to color the white gesso ground in some manner. I applied a gray (umber, ultramarine blue, and white gesso) which I then covered with a glaze of burnt umber. Upon this warm, medium gray tone, all the colors that were mixed with white (gesso) registered their presence at once, vigorously. The same brushes were used as in the previous example of mural painting, round and flat bristle brushes in addition to a large round sable brush.

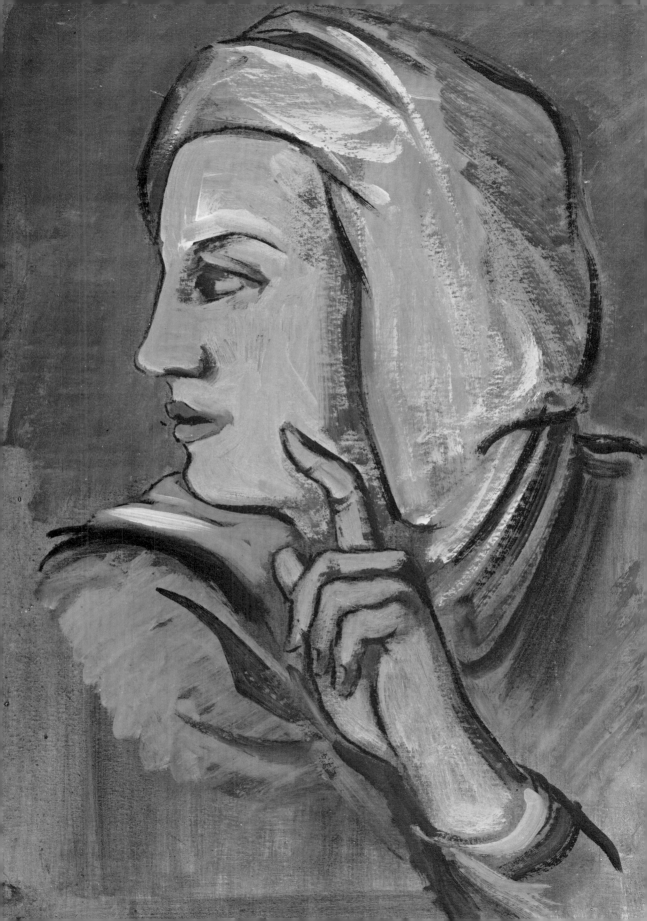

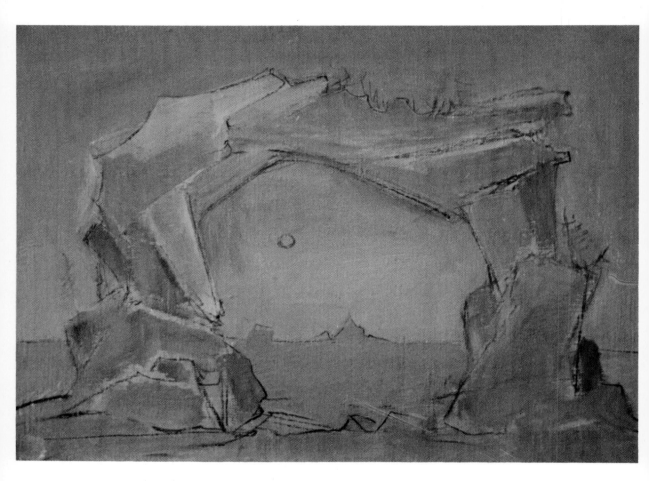

The Stone Bridge (Second Underpainting). This is actually the second underpainting (the first is not shown). The initial coloring (red oxide and white gesso) has become more elaborate (yellow oxide, umber, and white gesso) in order to differentiate the strata of rock. (Both underpaintings were done in acrylic colors as a base for an oil overpainting.) Also, the drawing, almost entirely obliterated by the first underpainting, was developed in some detail with charcoal on top of the second underpainting.

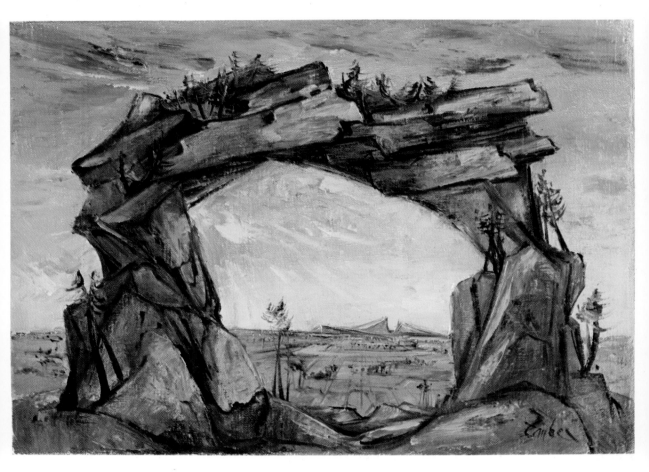

The Stone Bridge (Final Painting, Mixed Technique). After establishing the second acrylic underpainting, which dried almost instantly, the surface was oiled with copal painting medium. Oil paint was then applied over the entire surface with the painting knife alone. Ample evidence of interchanging glazes and impasti can be seen in the rock parts and, to a lesser degree, in the area of the sky. In addition to the painting knife, a large round sable brush was used. I also used one small and one larger scriptliner and a striper. Done on 16″ x 20″ stretched canvas. (See detail on following page.)

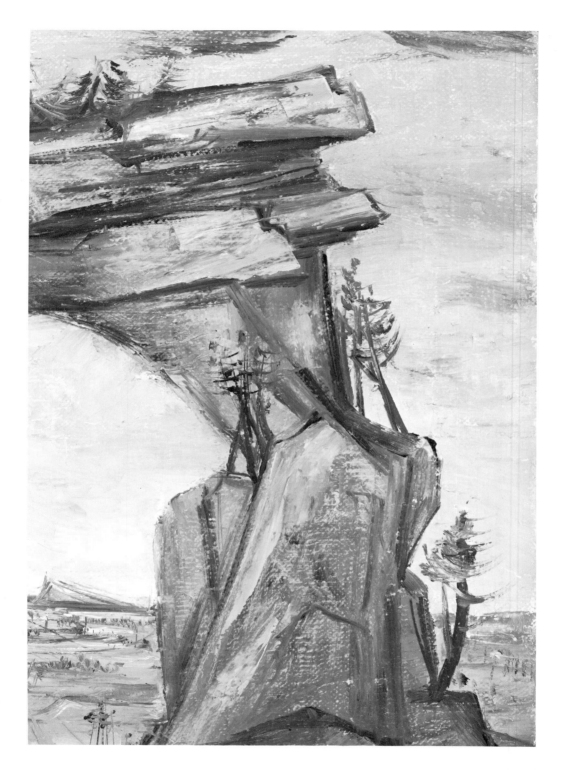

(Above) Detail of *The Stone Bridge*.

(Right) **Girl Dressing** (Preliminary Sketch). This preliminary sketch was done with charcoal in some detail to establish the strong light and shadow contrasts.

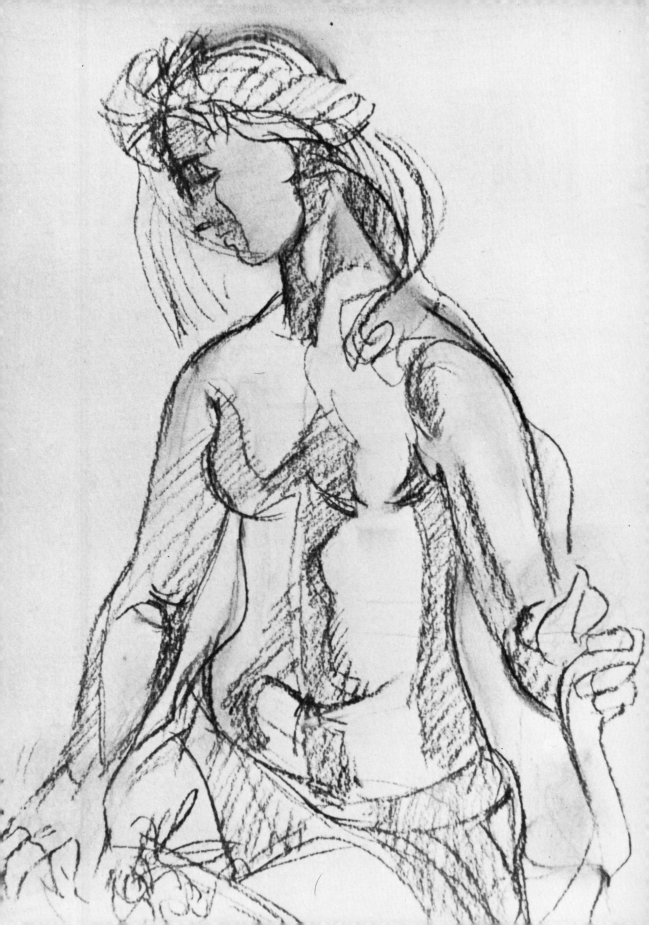

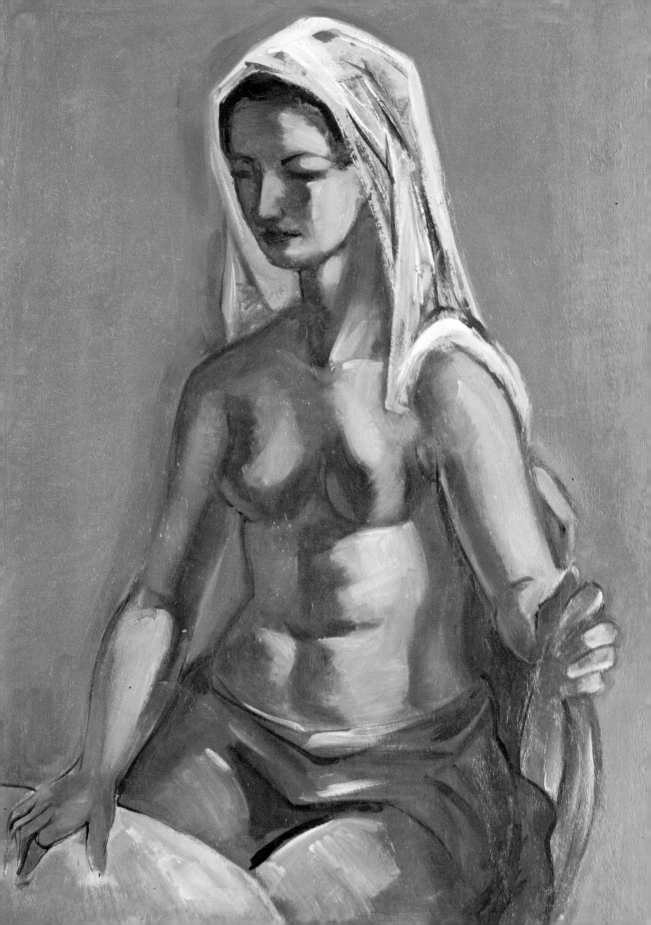

(Left) **Girl Dressing** (Mixed Technique). This painting, done on a 25″ x 18″ panel, shows a preponderance of shadows. In fact, three-fourths of the body is in shade. For underpainting the flesh, carried out with no modeling, a grayish acrylic color (phthalo green, red oxide, and white gesso) was used. The color of the veil and the top of the table were done with yellow oxide and white (gesso). The pink wrap, as well as the blue background, was also underpainted without modeling. The following oil colors went into the overpainting of the flesh: Venetian red, ochre, umber, ultramarine blue, and white. Because of the cool color of the acrylic underpainting, I chose a rather warm tonality for the superimposed oil colors and allowed the underpainting to reappear in the areas of half-shadows and reflections. Chromium oxide green and ultramarine blue (for the dark accents) were used for the background; the drapery, originally a pink color, received an oil overpainting of an identical color. I used flat bristle and round sable brushes.

(Above) Detail of *Girl Dressing*.

11/MIXED TECHNIQUE:
OIL COLORS ON ACRYLIC UNDERPAINTING

In the preceding chapters, we discussed using acrylic colors exclusively, in ways dictated by the nature of the material. In the following chapters, we shall investigate a method that combines the advantages of the quickly drying opaque acrylics with the flexibility offered by oil, or rather oil-resin, overpaints. The advantages that oil colors offer are manifold: slow drying that allows free blending of colors during a day-long working period; the possibility of continued corrections while working wet-in-wet; greater variations of textures; and the occasion to use a painting knife.

Painting Knife

The painting knife is an instrument hardly ever employed in acrylic painting. The reason for this is that, to arrive at a final satisfying statement, knife work has to remain wet for longer periods of time so that previous applications can be rectified. The paint must also possess the necessary viscosity. This does not mean that you may not use the knife on certain occasions when working with acrylics in a traditional manner. Of course, it must be understood that not only the physical properties of the knife (or rather knives, for we shall use several) must be just right for the assigned tasks, but that to be effective its handling must be skillful and technically correct.

Acrylic Underpainting

Those devoted to oil painting, who find it difficult to adapt themselves to handling a technique that requires an entirely different approach, will discover that acrylics are very suitable for underpainting. Used for underpainting, acrylics do not require a perfect blending of tone and color; even an incomplete blending will serve us well.

Support

The mixed technique can be used either on canvas or on a panel, but when working on a canvas, the interstices of the fabric must first be well filled with gesso priming. It is very difficult to fill these interstices in when underpainting with a knife.

Mix Colors with White

Every one of our acrylic colors will have to be mixed with white (gesso or tube color) to impart luminosity to the subsequent painting. This must be done no

matter how many (one or several) underpaintings we use. One may ask, at this point, on what occasion there will be a need for more than one underpainting. There should be more than one underpainting whenever we think that the composition, as well as the anticipated color scheme, may require a rectification or elaboration.

Scumbles

As we know, glazes can be applied only on light surfaces. But how about scumbles? Why not prepare surfaces suitable for scumbling in advance? The answer is simple: in the oil medium, scumbles are most effective when done into wet paint. Thus, a dark underlying oil color can be provided at any time and on any dry acrylic surface — be it light or dark — then scumbled over with light oil paint.

Impasto

It is good practice to avoid impasti in the underpainting unless they are judiciously placed and you are able to exploit them for the final effects. A thin painting on top of an incongruous texture left by heavy brushwork would not be able to assert itself either coloristically or texturally.

Palette

First, we shall arrange our oil colors on the palette. With certain changes, however. Instead of acrylic phthalo green, the oil color will be viridian green, and instead of acrylic phthalo blue, we shall use the oil color Prussian blue. We shall need the oil color Naples yellow, and instead of acrylic yellow oxide, the oil color ochre; Venetian red will be the name in oils for acrylic iron oxide, and ivory black will replace acrylic Mars black. Finally, we shall use flake white for our white color. The nomenclature of the other colors will be the same as in acrylics: raw and burnt sienna, raw and burnt umber, cadmium yellow light, cadmium orange, cadmium red, and alizarin crimson.

Oil Color Conditioners

The viscosity (that is, the capacity of these oil colors to blend), as well as their depth and brilliance, will be greatly improved when they are conditioned with an ingredient known as *Copal Concentrate*. This is a thick, honey-like substance, combining copal hard resin and stand oil (linseed oil processed thermally in the absence of air).

The concentrate should be scooped out of the bottle with a painting knife, and as much as its tip will hold should be mixed with every inch of color placed on the palette. Copal concentrate is not a paint thinner; for this purpose we shall require *Copal Painting Medium*. This comes in a heavy and a light consistency, the first being more viscous, hence more suitable for *alla prima* painting (discussed in Chapter 12). These preparations, manufactured by Permanent Pigments of

Cincinnati, Ohio, employ formulas known since the Middle Ages and proven by use and research to be superior. It should be mentioned that products on the market designated as "copal" differ in their composition and many may prove to be entirely unsuitable for the designated purpose.

Preparing Acrylic Surface for Oils

Before starting to paint with oil colors, the first step is to "oil" the acrylic surface. This means rubbing copal painting medium into it. When using oil paint, a dry surface should always be moistened with medium prior to working on it.

12/LANDSCAPE IN MIXED TECHNIQUE

The mixed technique is illustrated in *The Stone Bridge* (see demonstration on pp. 100 and 101). This painting was done on a rather coarse 16" × 20" stretched canvas. It carried four gesso primings and two acrylic underpaintings.

First Underpainting

The first acrylic underpainting of *The Stone Bridge* (not shown) was rather tentative; it covered the sky area with a pink color (red oxide and white gesso). A prevailing bluish tone (the expected coloring of the sky) always acts well on a warm underpainting, especially if one does not plan to use the overpaint opaquely. Also, a light pink in the underpainting imparts great luminosity to a semitransparent film of color.

A still greater luminosity could have been achieved in the sky by using the same yellowish underpainting that was used in the mass of rock. The rock was finished in a rather dark opaque, and in parts semiopaque, manner. The yellowish underpainting gives it a feeling of warmth.

Second Underpainting

In the second acrylic underpainting of *The Stone Bridge,* the initial coloring became more elaborate (yellow oxide, umber, and white gesso) in order to differentiate the strata of the rock. Also, the drawing, which was almost entirely obliterated by the first underpainting, was developed in some detail with charcoal. Here, the importance of the procedure carried out thus far becomes obvious — the compositional changes in the underpaintings bring about a gradual maturing of the initial tentative idea.

Applying Oil Color

After establishing the second underpainting in acrylics, which dries almost instantly, the surface was oiled with copal painting medium. Oil paint was then applied over the entire surface with a painting knife alone. The knife is not only capable of producing intriguing impasti, but when you scrape the top grain of the canvas almost free from paint, leaving paint imbedded in the interstices, you can achieve perfect glazing effects. Ample evidence of interchanging glazes and impasti is present in the rock parts and also, to a lesser degree, in the area of the sky.

In addition to the painting knife, only one large round sable brush was used, as well as one small and one larger scriptliner and a striper.

Deciduous and Evergreen Trees

First, we shall sketch a deciduous tree and an evergreen tree (see finished trees on p. 77). Both of these — because they are verdant — will be underpainted in a yellow acrylic color to give a liveliness to the green oil color painted over it. Of course, if an entirely opaque overpainting is used, the value of its underlaying color is immaterial. The color of the trees is held in lower key when seen from a distance, and in higher key when they are observed close up.

The trees were underpainted in an acrylic mixture of cadmium yellow and white (gesso). The surface of this underpainting was rendered quite smooth, and upon drying (to emphasize it again, the underpainting must be *entirely dry* before painting on top of it), a rather thin glaze (oil paint thinned with copal painting medium) of Prussian blue and burnt sienna oil colors was spread over its entire surface. The configurations of the foliage and the needles were then painted into the wet glaze with Prussian blue and burnt sienna. A round sable brush was used for the foliage; a scriptliner was used for the needles. The same brushes were used in the application of the lights which were thickly painted with a mixture of cadmium yellow and white.

Treetrunks

We could paint the treetrunks in the same manner as the foliage and the needles, but here we treat them — for a change — with impasto. And since impasti can be done easily with acrylics alone, if they are not blended too much, follow the directions for painting treetrunks with acrylic colors found in Chapter 8.

Rock Formations

The rock shown in the photograph opposite shows round conformations of a smooth surface. The painting done from this rock (*Fantastic Rock Formation,* demonstrated on pp. 111 and 112) was underpainted in acrylic grays and pale yellows (yellow oxide, black, and white gesso). For the oil color overpaint in the shadow parts, burnt sienna and ultramarine blue were used thinly enough to make the underpainting assert itself here and there. In the light areas, ochre, umber, and white oil colors give the mass of stone its weight and volume.

The photograph on p. 113 represents a detail from the painting *St. Francis,* by Giovanni Bellini (Frick Collection, New York). Because this is one of the paintings from which I have derived much inspiration — and instruction — I couldn't resist the temptation to present this magnificently rendered rock to the reader. A study of this detail will reveal its technique, which is closely related to the one seen in my painting of it demonstrated on pp. 113 and 114, with one exception: the underpainting in my painting was held in a middle tone and received a light scumble. When referring to "scumble," the presence of white in the not quite opaque mixture is implied. Thus, the light, solid underpainting was followed by a light, less "solid" (that is, more liquid) application of a closely related oil color.

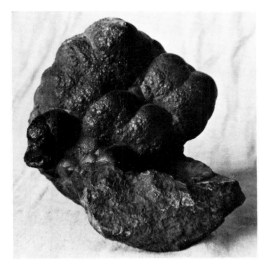

(Left) This photograph shows the small rock that was used as a model for *Fantastic Rock Formation.*

(Below) **Fantastic Rock Formation** (Underpainting). This acrylic underpainting was done in grays and pale yellows (yellow oxide, black, and white gesso). The drawing was done on top of the underpainting with a scriptliner.

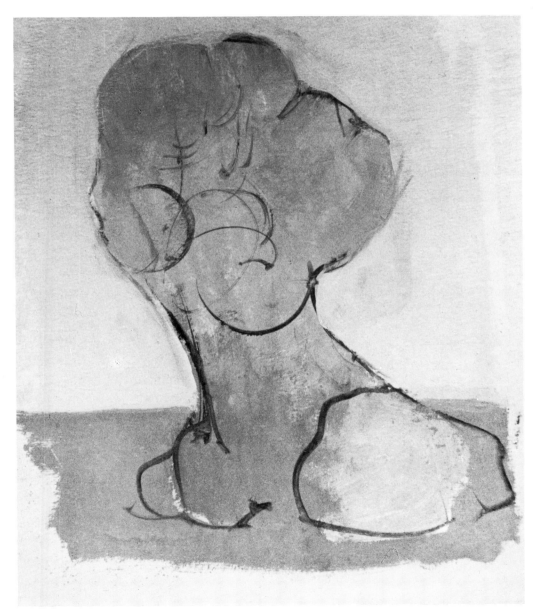

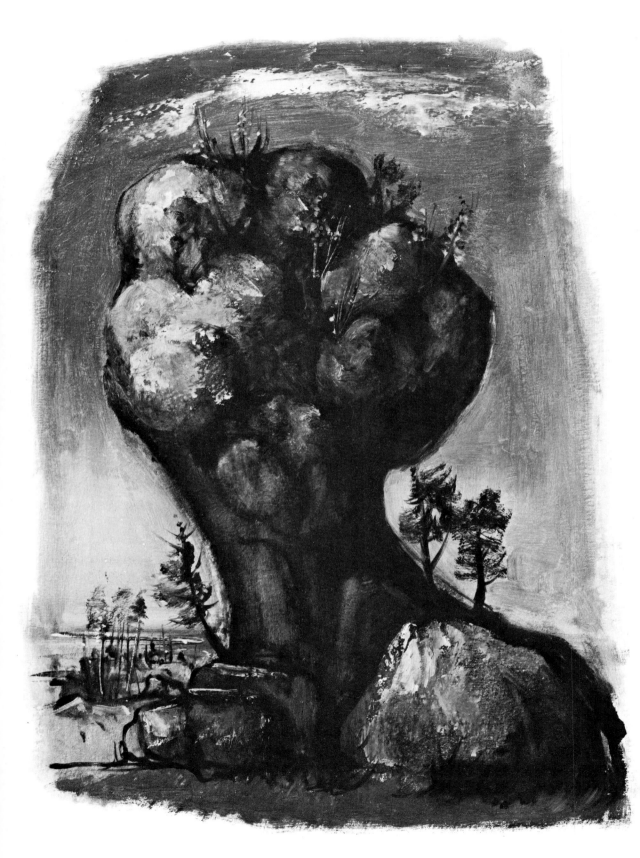

This photograph shows the detail from *St. Francis* by Giovanni Bellini (Frick Collection, New York) that I used for *Study of St. Francis Rock Formation*.

Study of St. Francis Rock Formation (Underpainting). This acrylic underpainting, held in a middle tone, received a light scumble. When referring to "scumble," the presence of white in the not-quite-opaque mixture is implied. Thus, the light, solid underpainting was followed by a light, less "solid" (that is, more liquid) application of closely related oil colors.

(Left) **Fantastic Rock Formation** (Final Painting, Mixed Technique). Burnt sienna and ultramarine blue oil colors were used for the overpaint in the shadow parts. These were applied thinly enough so that the acrylic underpainting could assert itself here and there. In the light areas, I used ochre, umber, and white oil colors to give the mass of stone its weight and volume. Done on 18" × 12" illustration board.

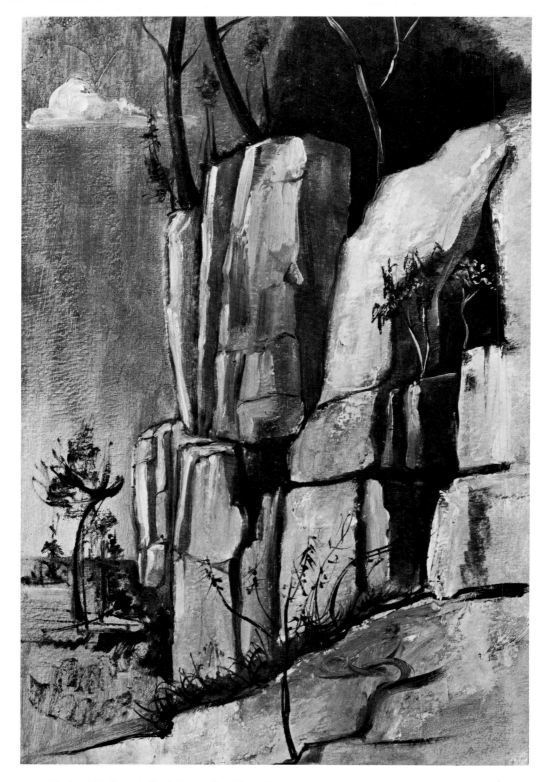

Study of St. Francis Rock Formation (Final Painting, Mixed Technique). The uniformly light acrylic underpainting of the rock was finished by modeling the areas in shade with glazes mixed from ultramarine blue and burnt sienna oil colors. White, umber, and ochre oil colors went into the painting of the light parts. A flat sable brush and a painting knife were used for the broader definitions, and a scriptliner and a striper for the details. Done on 18" × 12" illustration board.

13/STILL LIFE IN MIXED TECHNIQUE

In Chapter 7, still life compositions were executed entirely with acrylics. Now we shall study still life using oil colors on top of acrylic underpainting.

Wood Grain

In the photographs on p. 65, textures of cut lumber are seen. The first is pine, the second, oak. When painting still lifes, this question will inevitably arise: where should we place the objects? Should the surface of a table be considered (if not covered by some fabric), the grain of the wood will offer us intriguing pictorial possibilities. How can we best represent it? In the demonstration of *Wood Grain* on p. 66, the grain of the wood surface was established in a solid layer of acrylic yellow oxide and white (gesso), representing the lightest color of the object (A). If a lighter effect is needed, more white can be added.

The representation of the wood grain was carried out in the following manner: the acrylic underpainting was covered evenly with an oil glaze of burnt umber; this oil color was thinned with copal painting medium, producing a middle tone which is neither too dark nor too light (B). The oil color stayed soft long enough to allow the prolonged manipulation needed to produce the graining, which was simply scraped into it with a painting knife, revealing the light color from within (C). When working with oil colors, as usual, the darkest as well as the lightest accents should be the last to be applied (D). The darkest accents were painted with pure umber, slightly diluted with medium, using round sable brushes and a scriptliner for the continued linear definitions; the lightest accents were painted with ochre and white. The entire operation was carried out wet-in-wet.

Glazes

In painting the *Wicker Basket* shown in the demonstration on pp. 119-121 (see photograph on p. 119), a similar technique was employed, with the exception that the light color was not derived from the acrylic underpainting. The light color was applied with impasto into the wet umber glaze painted on top of a middle tone underpainting. This middle tone was mixed from the acrylic colors, umber, yellow oxide, and white (gesso). To avoid brushmarks, the acrylic underpainting was applied with a flat sable brush, then flattened with a palette knife. Next, the basket was sketched in (you can use either greatly diluted paint or charcoal). A glaze of umber oil color was applied to approximate the density of shadows in the areas where they occur. Then the design of the wicker was indicated with a scriptliner.

For this purpose, I used umber, and where very dark — almost black — accents were required, I mixed the umber with ultramarine blue. Lastly, the lights were painted with ochre mixed with white and the colors were blended with a soft hair blender.

Moving into a different area, let us consider painting some colorful objects from the produce department. First, we shall start with the *Apples* shown in the demonstration on pp. 122 and 123 (see photograph on p. 122). The procedure is identical with that described in painting the boards in *Wood Grain*. On a smooth acrylic underpainting of cadmium yellow, the apples were modeled with alizarin crimson oil color. Ultramarine blue oil color was added to produce the deepest shadows. Lastly, the highlights were obtained by wiping off the glaze, so as to bring out the yellow from within. Of course, such an operation is feasible only as long as the glaze is still wet.

In painting the *Pineapple* shown in the demonstration on pp. 74-76 (see photograph on p. 74), the initial steps were identical with those used in the preceding example. The raw sienna acrylic underpainting was glazed with a mixture of viridian green and burnt sienna oil colors. Then the design of the surface texture was included and its deepest accents were painted, using the same oil colors. All the lighter definitions were then painted, using ochre, white, and a dash of burnt sienna oil colors. For the leaves, Prussian blue, cadmium yellow, and white oil colors were used. These, as well as the light areas of the fruit, were painted with bristle brushes. The background was painted with a palette knife.

The painting of *Grapes* shown in the demonstration on pp. 84-86 (see photograph on p. 84) repeats our characteristic glazing procedure. On an acrylic underpainting of dull, pale yellow (yellow oxide and white gesso), the entire surface was glazed with viridian green oil color. This established our middle tone (the color of the grapes was green). For the parts in shade, viridian green was mixed with ultramarine blue, cadmium yellow, and a touch of burnt sienna oil colors. Next, the contours of the grapes were indicated with a small round sable brush; their reflections were obtained by wiping some of the glaze off (also with a round sable brush). Then the areas in light were painted with a mixture of viridian green, cadmium yellow, and white oil colors. Finally, the painted surface was blended with a flat sable brush.

Opaque Colors

In contrast to the preceding examples, which were treated predominantly in glazes, we shall now paint with colors that appear quite opaque. To start with the simplest objects — for example, the *Eggs* shown in the demonstration on pp. 90-92 (see photograph on p. 90) — we may ask: what purpose would an underpainting serve for this monochromatic object? Chiefly to make the body of the paint more substantial and to fill in the interstices of the support which would otherwise interfere with effective overpainting.

Note: before painting with oil colors, the acrylic underpainting should be oiled

with copal painting medium. The medium should be rubbed into the surface of the underpainting with a brush. The reason for this procedure is to facilitate the brushwork, which will move more effectively; also, the paint blends more easily on a surface thus treated. In previous examples, where glazing was employed as our first operation, oiling was not needed because the glaze itself produced the necessary oiling effect.

In the finished painting of *Eggs,* the objective was to produce the softest transitions of color and contour possible. Although fusion of paint becomes easier when using copal painting medium and copal concentrate, in certain instances (where maximum fusion is desired), the use of a flat sable brush and a soft hair blender (made of squirrel hair) appears to be essential. These were used for transitions of color on the eggs and for blending their contours. The paper support, however, received a rough texture created with the flat bristle brush.

In *Study of Winged Victory of Samothrace* shown in the demonstration on pp. 124-126 (see photograph on p. 124), a similar monochromatic tonality prevails, but unlike the preceding example no thorough blending of paint was attempted in the acrylic underpainting. The impasto brushstrokes were left on purpose to emphasize the personal "handwriting." When blending paint thoroughly (as in the preceding example), the specific character of brushstrokes becomes completely obliterated.

Glazes and Opaque Color

The arrangement of *Still Life with Glass Objects* (see demonstration on pp. 94-96) is somewhat more complex. Here, transparencies and opacities interchange throughout the composition (see photograph on p. 94). Since the colors of the glass are monochromatic — with no colorful background to impart its own chromatic effect — we shall underpaint the objects in a variety of acrylic grays (umber, phthalo green, a little yellow oxide, and white gesso). The lighter grays will give us the opportunity for glazing, and the darker grays for scumbling, with opacity applied here and there. Because of the nature of the subject and the extent of the composition, more than one underpainting seemed to be indicated. Experience teaches us that through successive elaborations of the underpainting, the pictorial fabric of the whole can be greatly enriched. But this is not a rule. In this instance, it seemed to be advantageous to seek a design based on geometric patterns and a pictorial treatment leaning toward the "open color" method.

The following oil colors were used in the finished painting of *Still Life with Glass Objects:* umber, burnt sienna, Naples yellow, Prussian blue, viridian green; a rather narrow range, relying on differentiation of tonal values.

Transparent Color

Thinly applied paint need not always be looked upon as a glaze; it is the condition of transparency that gives it this designation. Moreover, it should be understood that true glazes never employ white in their mixture. Thus, our next example, the

Drapery shown in the demonstration on pp. 127-129 (see photograph on p. 127), was painted neither with glazes nor with impasto, but with a consistency of paint that, without directly revealing its underlaying color, made its presence felt in some manner. The underpainting was a dark pink (burnt sienna and white).

In contrast to this example, in the study of *Draped Head* shown in the demonstration on pp. 130-132 (see photograph on p. 130), a nonrealistic approach was attempted, with emphasis on linear definitions and neglect of the three-dimensional appearance of the folds. The underpainting was yellow oxide and white (gesso). In both examples of folds, identical oil colors were used for the final painting: Prussian blue, umber, and white. The use of umber in this mixture is essential to achieve the darkest definitions of the blue. When examining the originals of both these paintings, it becomes apparent at once that the one underpainted in yellow possesses greater luminosity. Thus, the luminosity of a painted surface can be evident without the color from within that endows it with this quality being revealed.

Highlights

In our next example, *Still Life with the Head of Buddha* shown in the demonstration on pp. 133-135 (see photograph on p. 133), the bronze head received an acrylic underpainting of raw sienna and white (gesso). The deep, dark, brown-green patina of the fourteenth-century sculpture in the final painting was achieved by glazing the underpainting with a mixture of burnt sienna, Prussian blue, and viridian green oil colors. In the areas of light, the glaze was entirely removed from the underpainting; in the area of the deep shade it was quite dense. The teakwood base was also underpainted with raw sienna; the part in shade was glazed with umber and that in light was scumbled over thinly with yellow ochre, umber, and white oil colors.

The pewter candle holder in *Still Life with the Head of Buddha* was underpainted in light yellowish gray (yellow oxide, phthalo blue, and white gesso), and glazed with Prussian blue and umber oil colors. The highlights of the object were obtained by wiping the glaze off, thus revealing the light gray acrylic underpainting. Why were these highlights not painted with impasto, the common treatment on such occasions? The answer is simple: the intention was to avoid the tedious, commonplace practice of loading highlights with impasti. The background was underpainted in a bluish gray, then it received a pink color (Venetian red and white oil colors), with viridian green oil color added in the area obscured by shade. The copper vessel was finished in chromium oxide green opaque and Venetian red oil colors. The only strong color effects are provided by the candle — cadmium red in the light areas and umber added for indication of shade.

Brilliant Color

Flower Bouquet (p.71) was done on 13" x 9" panel on an acrylic ground of pale blue in the area of the background and yellow (cadmium yellow and white gesso) in the

center. Here, too, a painting knife and the same contingent of sable brushes was used as in the preceding example of *Still Life with the Head of Buddha.* For the sake of comparison, I used the same flower study as the one executed in pure acrylic colors entitled *Field Flowers* (p. 67) as an example.

In this instance, the final painting with oil colors was preceded by applications of films of brilliant oil colors — cadmium yellow dark, cadmium orange, and red spread with a knife very thinly over the yellow ground. The reason for this manipulation was to endow the superimposed colors with greater chromatic strength, so that they would impart a brilliance to the final colors. Of course, work was done wet-in-wet, with paint of high viscosity, often greatly thinned by medium, especially in the execution of linear definitions. These oil colors were used: ultramarine blue, Prussian blue, viridian green, Naples yellow, ochre, cadmium yellow light, medium orange and red, burnt sienna, alizarin crimson, and Mars violet.

A wicker basket, set up for the mixed technique study which follows.

(Above) **Wicker Basket** (Underpainting). This acrylic underpainting of umber, yellow oxide, and white (gesso) must show no brushmarks. Hence, the paint was applied with a flat sable brush, then flattened with a palette knife. Next, the basket was sketched in with a scriptliner, using greatly diluted acrylic umber paint.

(Right) **Wicker Basket** (Final Painting, Mixed Technique). A dark glaze of umber oil color was painted in the areas of shade. The design of the wicker was then reinforced with a scriptliner. For this purpose, I again used umber oil color. Where very dark—almost black—accents were required, I mixed the umber with ultramarine blue oil color. Last, I painted the lights with ochre and white oil colors and blended them with a soft hair blender. Done on illustration board.

Apples, set up for the mixed technique study which follows.

Apples (Underpainting). The entire surface was painted with acrylic cadmium yellow. The apples were drawn in with a scriptliner.

Apples (Final Painting). The apples were modeled with alizarin crimson oil colors on a smooth acrylic underpainting of cadmium yellow. Ultramarine blue was added to produce the deepest shadows. The lights were obtained by wiping off the glaze with a piece of cheesecloth to bring out the yellow acrylic underpainting underneath; in the highlight, the glaze was removed entirely. Of course, such an operation is feasible only as long as the glaze is still wet. Done with bristle brushes on illustration board.

I used this photograph of *Winged Victory of Samothrace* (Louvre) as the basis of the mixed technique study which follows.

Study of Winged Victory of Samothrace (Preliminary Sketch). This sketch was done realistically with charcoal. If you examine the sketch, it is obvious that the final design (see final painting) was modified to more effectively emphasize the feeling of flight in the winged figure.

(Right) **Study of Winged Victory of Samothrace** (Underpainting). No thorough blending of paint was attempted in the dark, acrylic underpainting. The drawing was reinforced on top of the underpainting with charcoal.

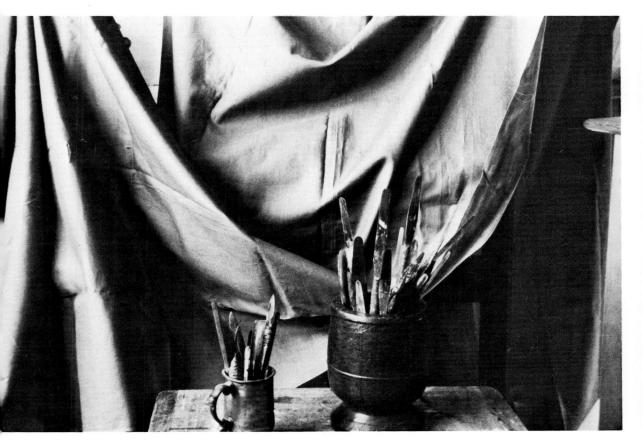

Only the drapery in this photograph was used in the mixed technique study which follows.

(Left) **Study of Winged Victory of Samothrace** (Final Painting, Mixed Technique). The final painting was carried out in grays only (umber, Prussian blue, and white oil colors), with no attempt to blend the detatched, freely moving impasto brushstrokes, which would obliterate the personal "handwriting." A monochromatic tonality prevails. Done with flat bristle brushes on 18" × 12" illustration board.

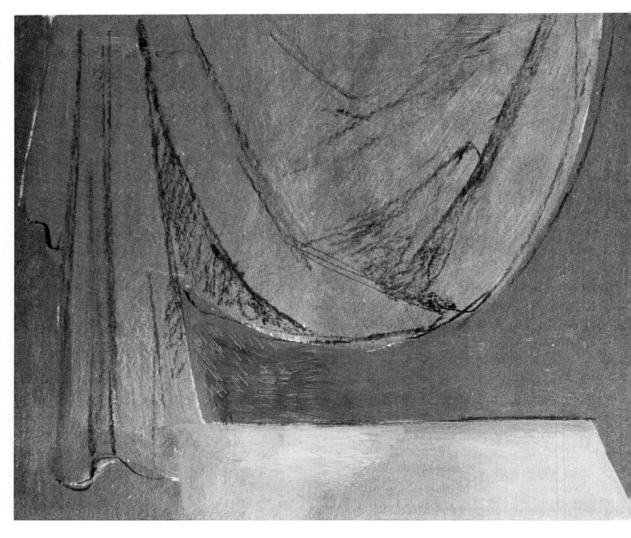

Drapery (Underpainting). This evenly colored acrylic underpainting was done in dull pink (burnt sienna and white gesso).

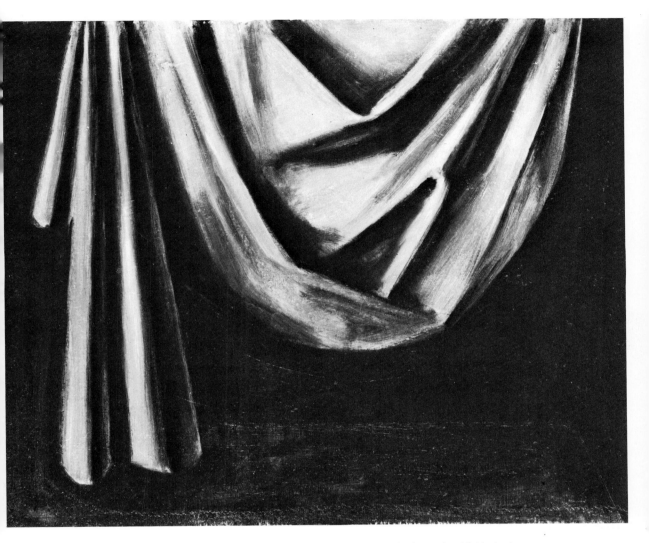

Drapery (Final Painting, Mixed Technique). The overpainting of this study of folds in drapery was blue (Prussian blue and umber oil colors), painted with flat bristle and round sable brushes. The reflections on the folds were obtained by partially wiping the oil paint off, allowing the dull pink of the acrylic underpainting to show through. The following invariable sequence appears in the light and shade relationship found in folds: deep shadow, cast shadow, reflection, highlight. On heavily textured or colored fabrics, of course, this sequence may not be as easily discernible. Done on illustration board.

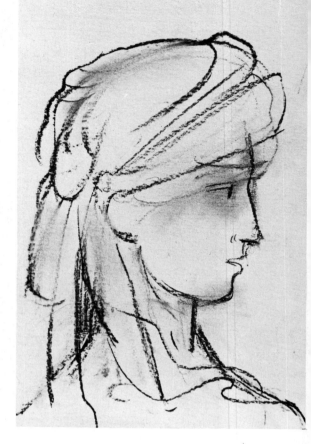

The model head seen in this photograph was used for the mixed technique study, *Draped Head.*

Draped Head (Preliminary Sketch). The featureless dummy is given a face and the basic lines of the composition are established in this charcoal sketch.

(Right) **Draped Head** (Underpainting). This thin acrylic underpainting was done with yellow ochre made from yellow oxide and white (gesso). The yellow color then received an acrylic blue overpaint.

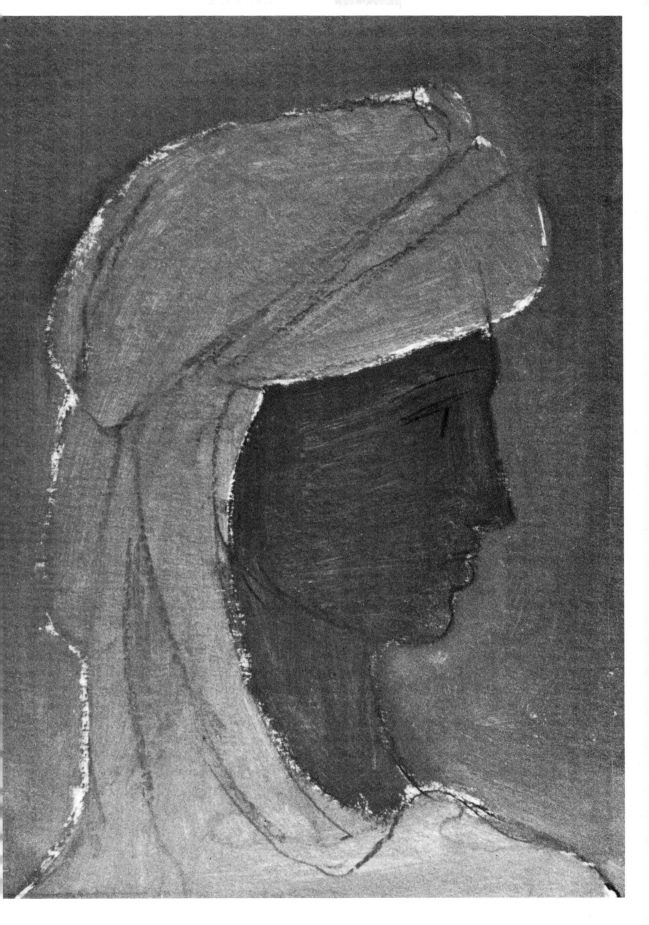

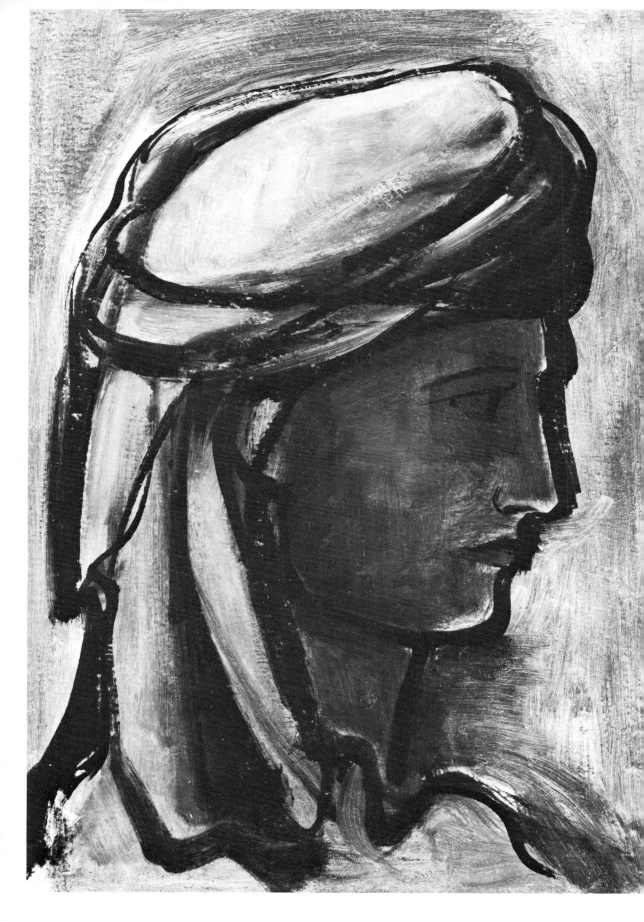

A photograph of the main objects used in *Still Life with Head of Buddha.*

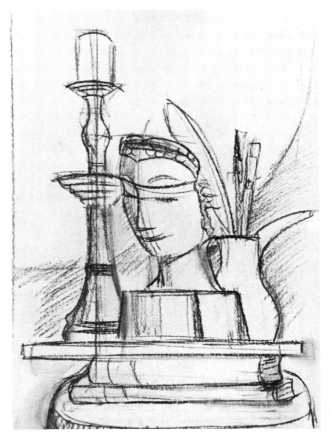

Still Life with Head of Buddha (Preliminary Sketch). A realistic drawing was made with charcoal of a formally arranged still life setting.

(Left) **Draped Head** (Final Painting, Mixed Technique). The background of this rather exotic head was painted in cadmium red oil color. For the bronze colored face, I used umber, burnt sienna, and white oil colors. Unlike the preceding example of realistic folds, the emphasis here is on the structural elements of the folds rather than on their bulk. These structural elements were indicated by purely linear means, with no suggestion of the third dimension. Done with a bristle brush, a striper, and a round sable brush on 18" × 12" illustration board.

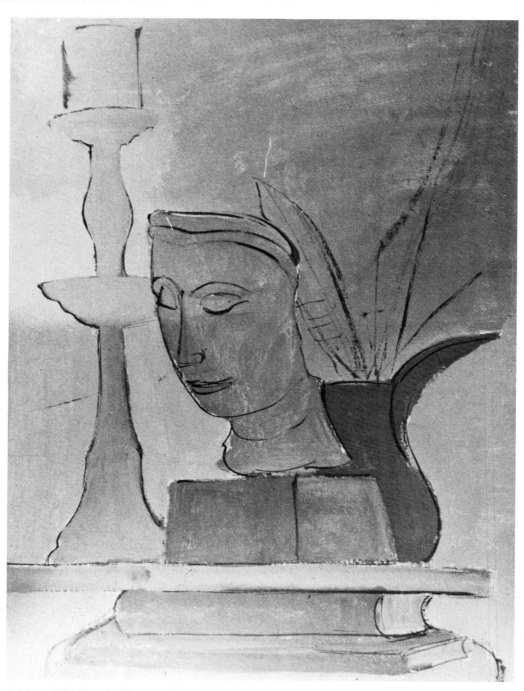

(Above) **Still Liife with Head of Buddha** (Underpainting). The bronze head and the teakwood base received an acrylic underpainting of raw sienna and white (gesso). The candle holder and the copper pitcher were done in acrylic yellow oxide, with a trace of acrylic phthalo blue and white (gesso). The background was an acrylic pale blue. The rest of the objects were given an acrylic underpainting of neutral color. The drawing was done with a scriptliner.

(Right) **Still Life with Head of Buddha** (Final Painting, Mixed Technique). In the oil color overpainting, applied as a glaze, the bronze head was done in burnt sienna, Prussian blue, and viridian green. The teakwood base was given an umber glaze in the shadow, an ochre and white scumble in the area of light. The candle holder was glazed with Prussian blue and umber; the highlights were derived from the acrylic underpainting. The background was pink (Venetian red and white) in the area of light and the same color darkened by viridian green in the area of shade. I used bristle brushes, a round sable brush, a scriptliner, and a painting knife. Done on 25'' x 18'' illustration board.

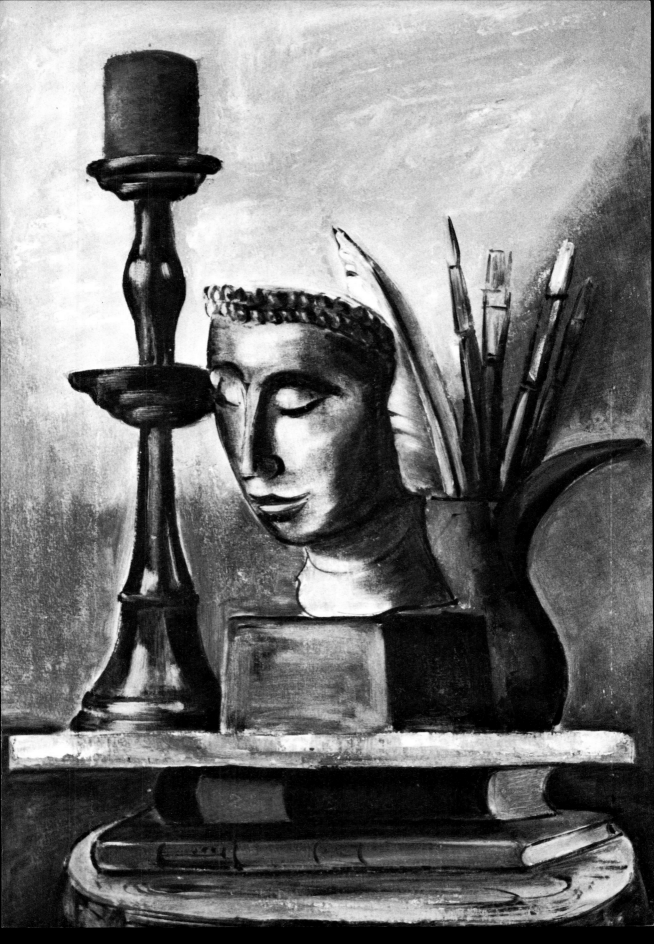

14/FIGURE AND PORTRAIT IN MIXED TECHNIQUE

On the preceding pages we have been discussing problems connected with the opacity and the transparency of paint in different circumstances. In painting flesh, we will be speaking more of the transparent quality.

Flesh Tones in Shadow

Girl Dressing on p. 104 (see preliminary drawing on p. 103), shows a preponderance of shadows. In fact, three-fourths of the area of the body is in shade. This should indicate to those who favor the use of glazes (as we see them on so many works by the old masters) that to paint such a large area of shade in opaque color would deprive it of an importance advantage — that of translucency. It is obvious that glazing provides a translucency of color and endows flesh darkened by shade with a particular charm unattainable by any other means.

Underpainting Flesh

For the acrylic underpainting of the flesh, carried out with no modeling, a grayish color was used — a mixture of white (gesso), phthalo green, and red oxide. Yellow oxide and white (gesso) went into the color of the veil and the top of the table. The wrap as well as the background were also underpainted without modeling — the first in pink (red oxide and white gesso), the second in blue. When comparing the original drawing with the final design, their divergence becomes at once obvious. More often than not we find that our original plan may require improvement!

Overpainting Flesh

The following oil colors were used for overpainting the flesh in *Girl Dressing:* Venetian red, ochre, umber, ultramarine blue, and white. Of course, depending on the prevalence of this or that color going into the mixture, entirely different tonalities can be produced. Because of the cool color of the underpainting, I chose a rather warm tonality for the superimposed color, and allowed the underpainting to reappear in the areas of the half-shadows and reflections. For the background, I chose chromium oxide green and ultramarine blue (for the dark accents); the drapery, originally a pink color, received overpaint in an identical color.

In the conventional *Portrait Done from a Model* shown on pp. 139 and 140, the following procedure was followed (as the reproduction of the *grisaille* acrylic underpainting shows, only the main masses were stressed; the details were omitted).

The coloring of the shadow parts as well as the hair was rather light, so as to allow glazing. Only raw umber and white (gesso) were used for underpainting the face; some yellow oxide was added in the area of the hair. The background is umber and white (gesso).

In the finished painting, done in oil colors, umber, Venetian red, ochre, and some white were used in the middle tones, with a little ultramarine blue added to this mixture for the darker effects; ochre, some umber, and white served for painting the light areas. The transparencies and reflections on the shaded part derive their luminosity from the light underpainting. Umber, ultramarine blue, and white were used for the background. Thus, only four colors went into the making of this study.

The great advantage of using acrylics for underpainting is that they dry instantly and enable us to proceed at once with oil color overpaints. An underpainting in oil colors requires one to several days to dry before it can be painted upon. On the minus side, however, we find certain limitations imposed upon us when using acrylics. For example, it is difficult to blend color passages or to model a surface with ease.

Modeling

Consider *Girl Dressing* again. The relatively large surface of the body, seen in strong light and shade contrasts, did not receive any modeling — it remained perfectly flat and undifferentiated. A more elaborate method would have called for modeling in *grisaille,* with a well-defined *chiaroscuro.* To say that this cannot be done in acrylics would be inaccurate, but to undertake continuous "patching up," retouching, crosshatching, etc., is just too much hardship — even for the most patient practitioner. It is best to save modeling for the oil overpainting; when sufficiently opaque, oil paint will cope well even with a roughly executed underpainting.

Contour

Then we have the outer contour to contend with. Should we wish to have a very soft contour (such as the *Eggs* on p. 92), blending the underpainting would simplify the task immeasurably. To take a drastic example, consider a blue sky meeting the land, which is yellow in color, at the horizon. Should we wish to have a mellow transition between the sky and the land, a hard edge in the underpainting dividing both elements would be most disturbing and not easy to cope with.

Last, it bears repeating: before using oil paint on an acrylic underpainting, rub copal painting medium thoroughly into the surface of your canvas, panel, or board.

Glaze and Opaque Color in Figure Painting

To realize the contrast between different techniques, I have chosen the same subject, *Study after Michelangelo* (p. 93), that is seen in the *Mural Painting after*

Michelangelo on p. 97. In this example, a panel carries an acrylic imprimatura of yellow oxide with some burnt umber added to lower its key. The presence of this color is clearly evident in all the areas that received oil color glazes, such as the background and the parts of the face and hands in shade. On the garment, the initial imprimatura remained untouched in its original condition, marked only by a few, thinly applied brushstrokes to indicate the folds of the sleeve. Opaque passages are seen on the light parts of the face, the hands, and the turban.

The following oil colors were used for the flesh: ochre, Venetian red, burnt umber, ultramarine blue, and white. The background was painted with ultramarine blue and umber; the turban was painted with Venetian red, umber, and white; and the dark linear accents were made with Mars violet. Whatever appears as black on the picture was mixed from umber and ultramarine blue. Thus, only five colors and white went into the making of this study.

Another example is *Figures in Interior* (p. 87). This was done on a small 9" x 11" panel with interchanging brush and painting knife strokes. Much of its design was done in "open color," used chiefly on the two sections to the left and right. These originally carried an acrylic imprimatura of phthalo green. They were then glazed with viridian green oil color. Next, the figures, painted in light flesh colors, were outlined with the scriptliner in Mars violet and white oil colors. The middle section received an acrylic imprimatura of burnt sienna, on which the central figure was finished in a sketchy manner, relying largely on linear accents.

(Right) **Portrait Done from a Model** (Underpainting). Only the main masses were stressed in this acrylic grisaille underpainting. The parts in shade and the hair are rather light, to allow for glazing. Raw umber and white (gesso) were used for painting the face; some yellow oxide was added in the area of the hair. The background was underpainted in umber and white (gesso).

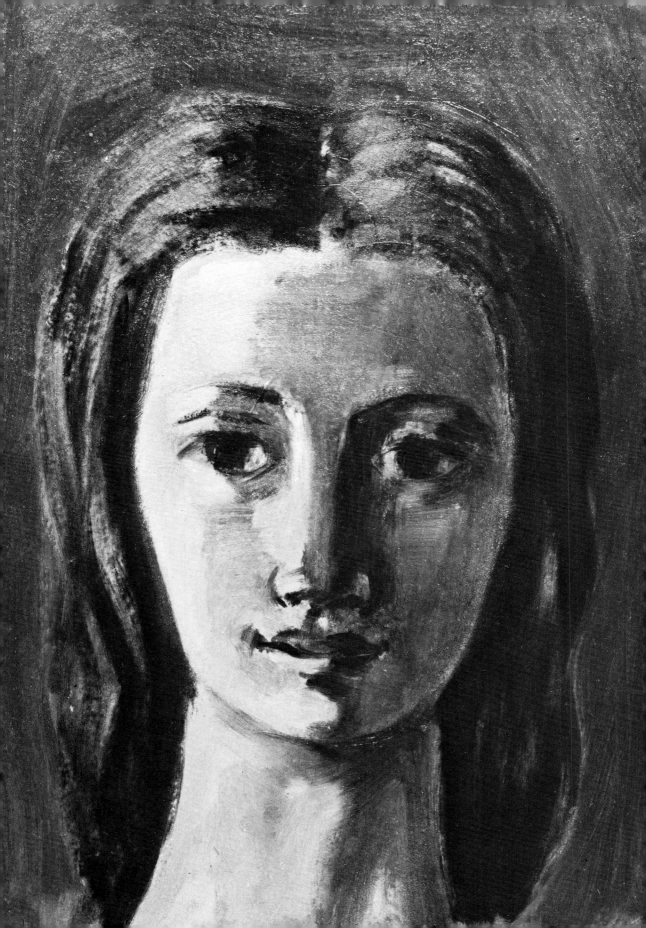

CONCLUSION

I have tried to cover all techniques suitable for use in representational painting with acrylics. That this relatively new material is more versatile and adaptable than any other aqueous medium is indisputable. It has none of the limitations of watercolor, none of the drawbacks of gouache, casein, or egg tempera. But it should not be compared to the oil medium, from which it fundamentally differs. In other words, one should not expect to achieve tonalities and mutations of colors such as we see in the paintings of the old masters (by which I mean the traditional schools of art that prevailed before the advent of the Impressionists).

In the techniques of these masters, the presence of an underpainting or an imprimatura was an intrinsic part of the procedure. Quite often, these preparatory steps were essential in achieving the qualities we admire in old master paintings. It is here, in the underpainting, that the acrylic material offers the great advantage lacking in oil colors — quick drying of opaque layers of paint, which eliminates the waiting time before starting the overpainting.

(Left) **Portrait Done from a Model** (Final Painting, Mixed Technique). The final painting was painted in oil colors; the part in shade was glazed. Umber, Venetian red, ochre, and some white were used in the middle tones; a little ultramarine blue was added for the darker areas; yellow ochre, some umber, and white were used for the lights. Done with bristle and round sable brushes on illustration board.

INDEX

A

Apples, demonstrated, 122, 123

Acrylic, characteristics of, 27, 28; chemical behavior of, 11, 12; colors, 26, 29; figure and portrait in, 136-140; gel. 24; in mixed technique, 106-140; landscape in, 45-50; list of, 26, 27; medium, 24; mixtures of, 28, 29; nature of, 11; permanence of, 11; placing of colors on palette, 27; premixing of colors for mural painting, 55; preparation of colors, 26; still life in, 36-39; technique demonstrated, 40-43, 48-50, 58-64, 67-70, 82, 83; technique illustrated, 45, 52, 67, 97-99; varnish, 24

B

Bark, 46; demonstrated, 48-50

Bellini, Giovanni, 110; illus. by, 113; study after, 113, 114

Bottles, demonstrated, 40-43, 94-96

Brushes, 20-23; bristle, 20; cleaning of, 24, 25; for mural painting, 54; sable, 23; scriptliner, 23; soft hair blender, 23; striper, 23

Brushstrokes, examples of, 22, 34

Buddha, still life with head of, 118; demonstrated, 133-135

C

Canvas, priming a, 14; preparing a, 13-15; stretching a, 13, 14

Cardboard, priming, 19

Casein, techniques with acrylics, 32

Colors, acrylic, 26-29; and glaze in mixed technique, 117, 137, 138; brilliant in mixed technique, 118, 119; characteristics of acrylic, 27, 28; list of acrylic, 26, 27; mixtures of acrylic, 28, 29; placing of acrylic on palette, 27; premixing of acrylic for mural painting, 55; preparation of acrylic, 26; chart of acrylic, 57; oil in mixed technique, 107; opaque in mixed technique, 116; open, 38; transparent in mixed technique, 117, 118

Concentrate, copal, 107

Conditioners, oil color, 107, 108

Contour, in mixed technique, 137

D

Demonstrations, in acrylic technique, 40-43, 48-50, 58-64, 67-70, 82, 83; in mixed technique, 65, 66, 74-81, 84-87, 91-97, 100-105, 111-114, 119, 135, 139, 140

Diluents, and varnishes and solvents, 24, 25

Drapery, demonstrated, 127-132

Driftwood, demonstrated, 58-61

E

Eggs, demonstrated, 90-92

Equipment, *see* Materials

F

Figure, and portrait painting, 51-53; and portrait in mixed technique, 136, 140; demonstrated, 102-104; illustrated, 52, 87

Flesh tones, in mixed technique, 136, 137

Flower painting, and still life, 36-43; illustrated, 67, 71

Foliage, 46; *see also* Trees

Fresco, 54

G

Gel, acrylic, 24

Glass, demonstrated, 40-43, 94-96

Glazes, acrylic, 30, 31; and opaque color in mixed technique, 117, 137, 138; chart, 73; examples of, 30, 31; in mixed technique, 115, 116; multiple, 31

Glazing, supports for, 30, 31

Gloss, 35

Gouache, technique with acrylics, 32

Grapes, demonstrated, 84-86

H

Highlights, in mixed technique, 118

I

Illustration board, priming, 19

Impasto, 35, in mixed technique, 107

L

Landscape, acrylic, 45-50; demonstrated, 68-70; 78-81, 101, 110, 111-115; in mixed technique, 109-114

Light, and shade in mural painting, 55

Line, illustrated in mural painting, 99; in mural painting, 55

M

Materials, and equipment, 13-23

Medium, acrylic, 24; copal painting, 107

Michelangelo, 55, 137, 138; mural painting after, 97-98; study after, 93

Mixed technique, 106-140; brilliant color in, 118, 119; contour in, 137; demonstrated 65, 66, 74-81, 84-87, 91-97, 100-105, 111-114, 119-135, 139, 140; flesh tones in, 136, 137; glaze and opaque color in, 137, 138; figure and portrait in, 136-140; highlights in, 118; illustrated, 71, 93, 97-99; landscape in, 109-114, modeling in, 137; oil colors on acrylic underpainting in, 106-108; painting knife in, 106; preparing acrylic surface for oils in, 116, 117; still life in, 115, 135

Modeling, in mixed technique, 137

Mountains, 46, 47; demonstrated, 69-70

Mural painting, 54, 55; illustrated, 93, 97-99; light and shade in, 55; fresco technique in, 54; line in, 55; premixing colors for, 55; preparation for, 54, 55

O

Open color, 38

Opaque, color combined with glazes, 117; color in mixed technique, 116, 117; scumbling, 33-35; technique, 45

P

Paint removers, 24, 25

Painting knife, 23; in mixed technique, 106

Painting medium, copal, 107, 117

Palette, acrylic colors for, 26-29; cleaning of, 24, 25; oil colors for in mixed technique, 107

Panels, priming Masonite, 19

Paper, 20

Pineapple, demonstrated, 74-76

Portrait, and figure painting, 51-53; and figure in mixed technique, 136, 140; demonstrated, 82, 83, 139, 140; preliminary drawing for, 51

Priming, canvas, 14; cardboard, 19; panels, 19

R

Rocks, 46, 47, 111; demonstrated, 68-70, 111, 112; illustrated, 44

S

Samothrace, Winged Victory of, 124; study after, 124-126

Scumbling, and opaque painting, 33-35; chart, 89; examples of, 33; in mixed technique, 107; technique of, 33

Shadow, in flesh tones in mixed technique, 136

Shells, demonstrated, 58-61

Sistine Chapel, 23

Solvents, diluents and varnishes, 24, 25

Still life, and flower painting, 36-43; demonstrated, 40-43, 58-64, 74-76, 84-86, 90-92, 94-96, 119-135; in mixed technique, 115-135

Supports, 13-20; for mixed technique, 106

Surface, preparing acrylic for oils in mixed technique, 108, 116, 117

T

Tone, illustrated in mural painting, 97, 98

Trees, demonstrated, 77; in mixed technique, 110

Treetrunks, 45, 46; demonstrated, 48, 49, 78-81; in mixed technique, 110

U

Underpainting, acrylic in mixed technique, 106; vegetation, 39

V

Varnish, acrylic, 24; and diluents and solvents, 24, 25

Van Gogh, Vincent, 35

Vegetation, underpainting, 39

W

Watercolor, technique with acrylics, 31

White, in mixed technique, 106, 107

Wicker, demonstrated, 119-121

Wood grain, demonstrated, 65-67, 115